JACK VETTRIANO

A MAN'S WORLD

For Amanda Jane

Jack Vettriano

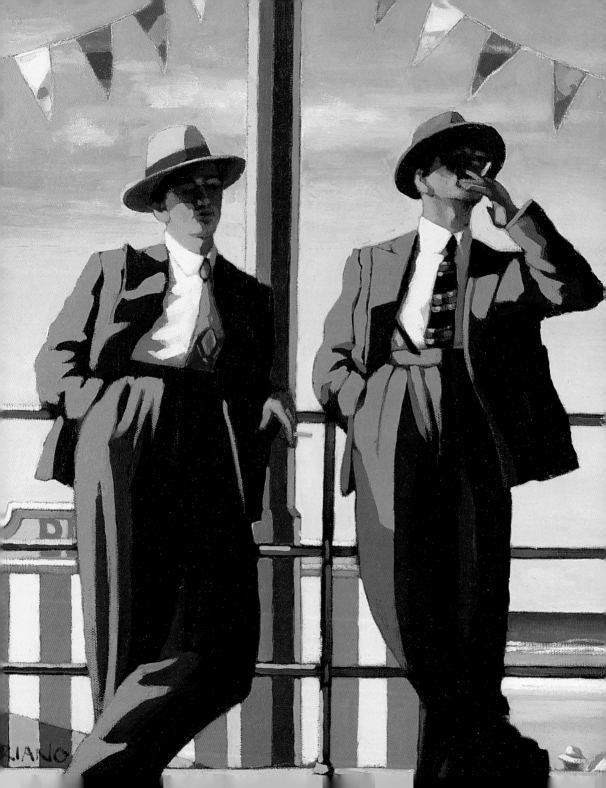

JACK VETTRIANO

A MAN'S WORLD

PAVILION

Previous page: Seaside Sharks

man

- noun (pl. men)

1 an adult human male.
2 a husband or lover.
3 a figure or token used in a board game.

My work relies heavily on narrative though I never much like to discuss the narrative, preferring as I do to allow the viewer to compose their own, perhaps more personal scenarios.

Men are less complete than women. Our wiring systems are geared for life on earth two million years ago. To have half the population of the world emotionally underdeveloped is an inescapable part of the human condition. So man soldiers on.

A Man's World contains some of the images which to my way of thinking best represent the emotional turmoil of man; from predatory to vulnerable, from cruel to sensitive and from hungry to bloated – my men are thus defined.

'I wish the women would hurry up and take over…it's going to happen so lets get it over with. Then we can finally recognize that women really are the minds and force that holds everything together and men are really gossips and artists.' Leonard Cohen. (*Leonard Cohen in his own words*, Jim Devlin, Omnibus Press)

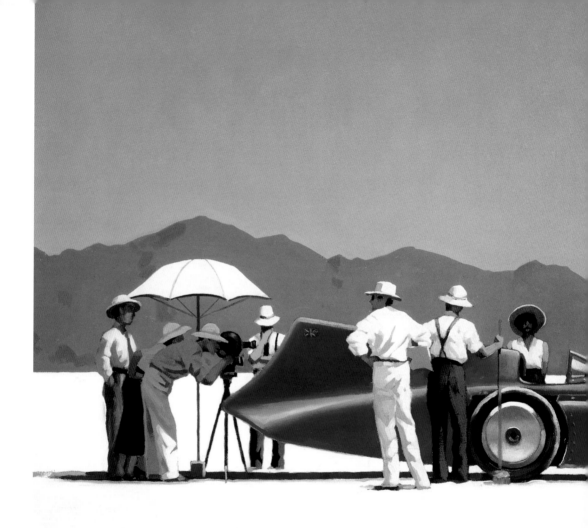

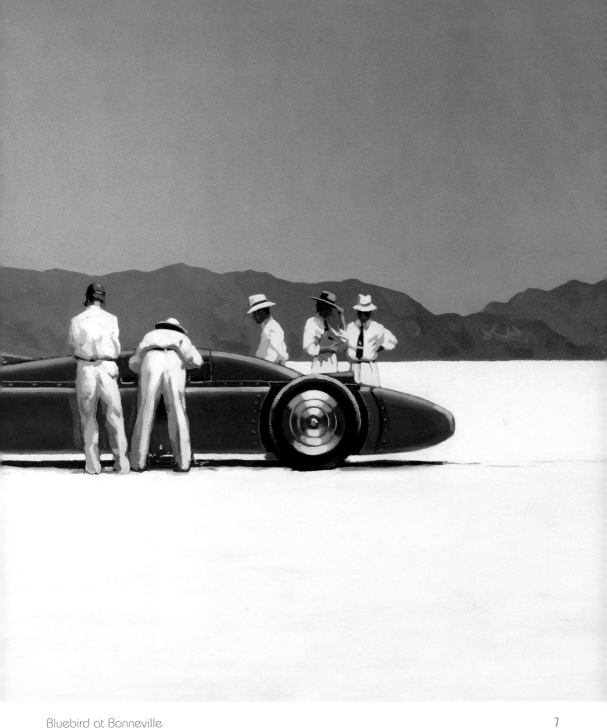

Bluebird at Bonneville

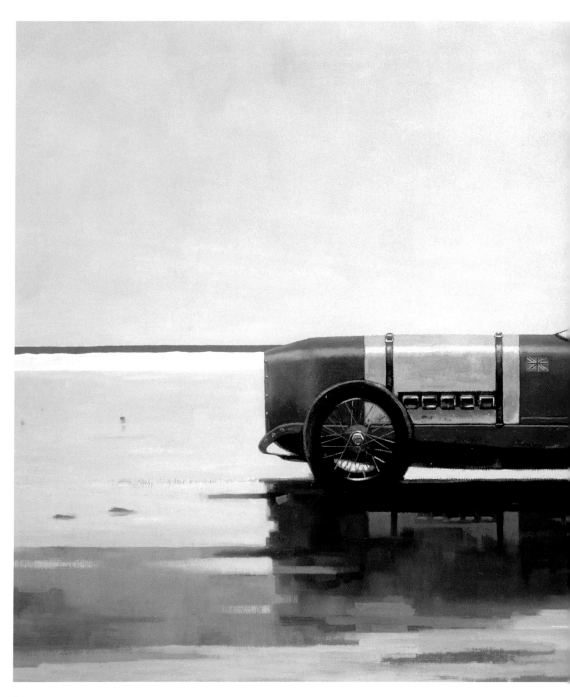

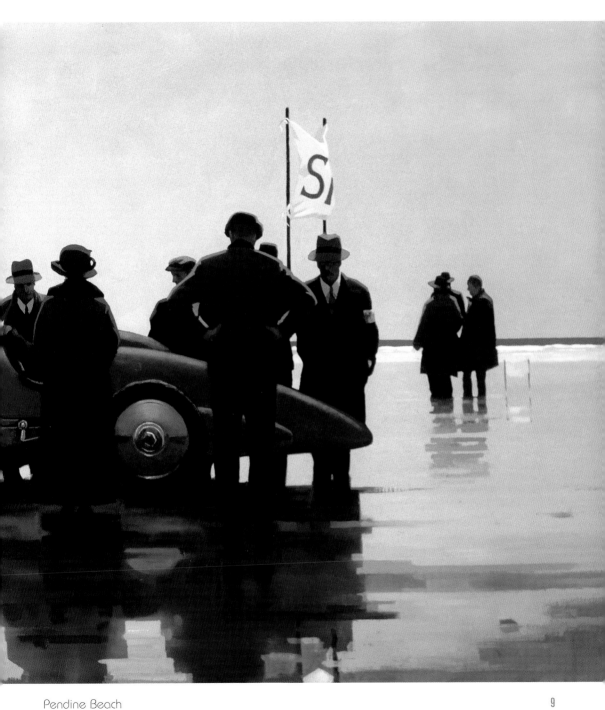

Pendine Beach

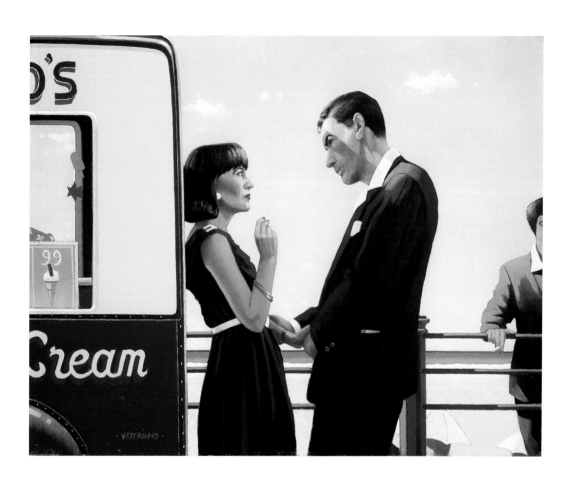

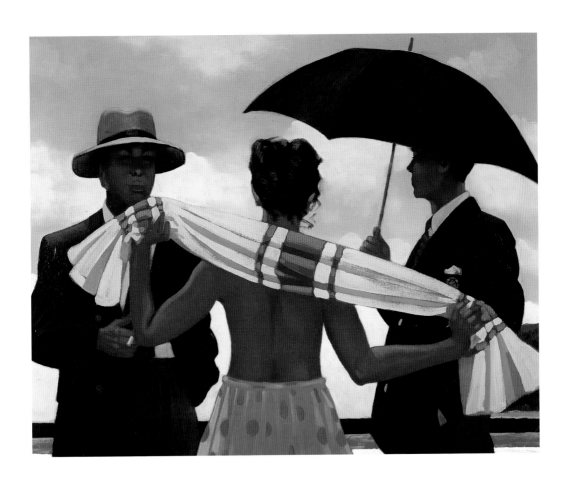

The Clouds are Gathering

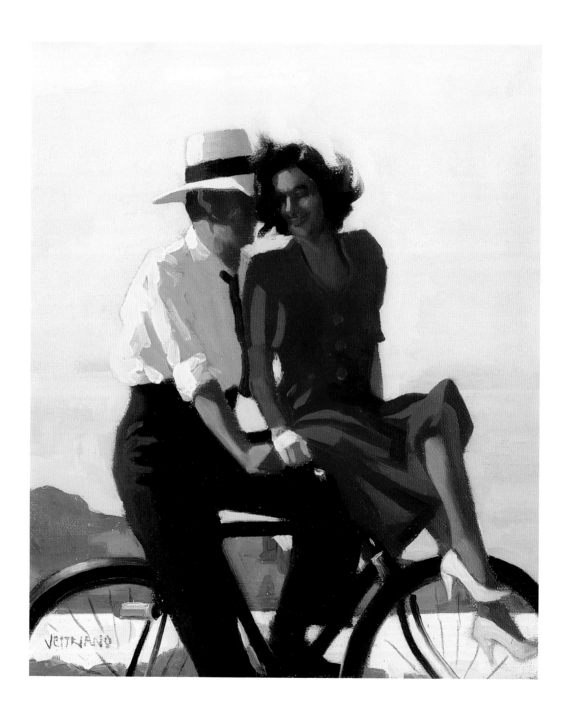

Lazy Hazy Days

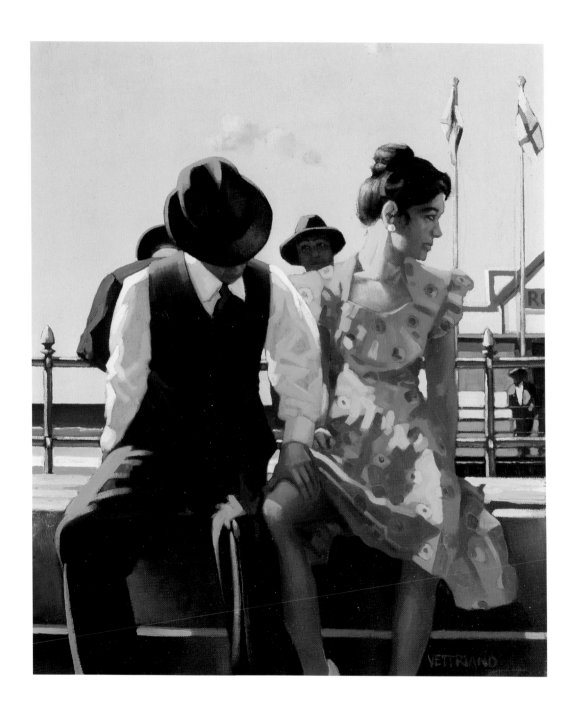

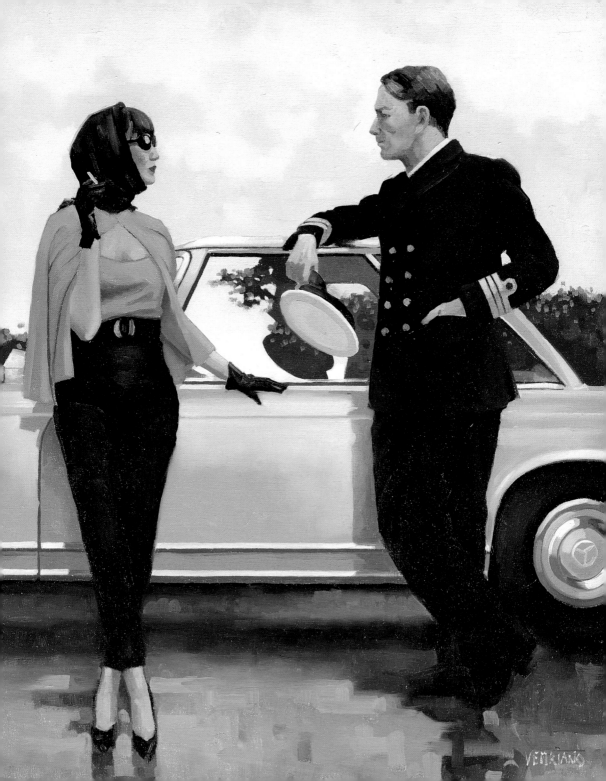

Suddenly One Summer II

Jealous Heart

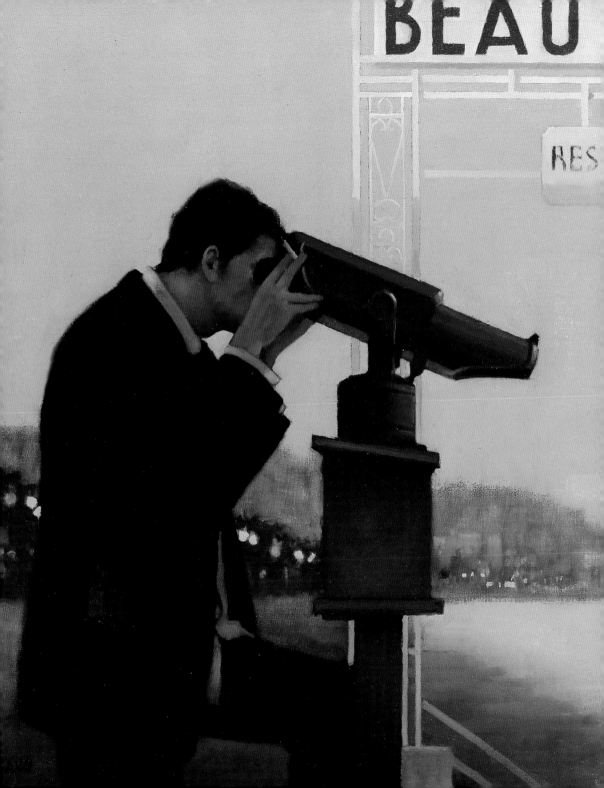

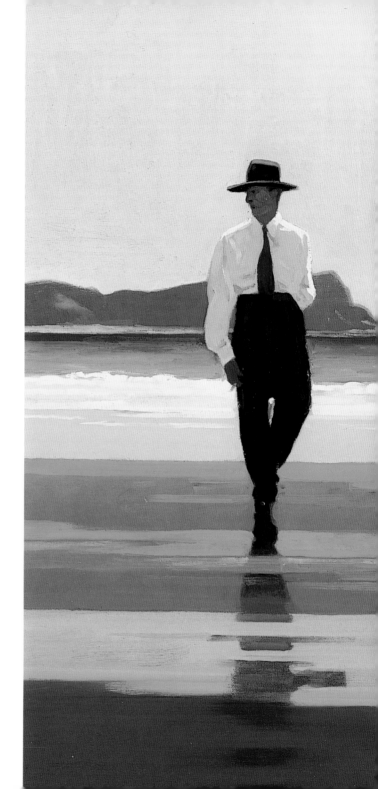

The Billy Boys

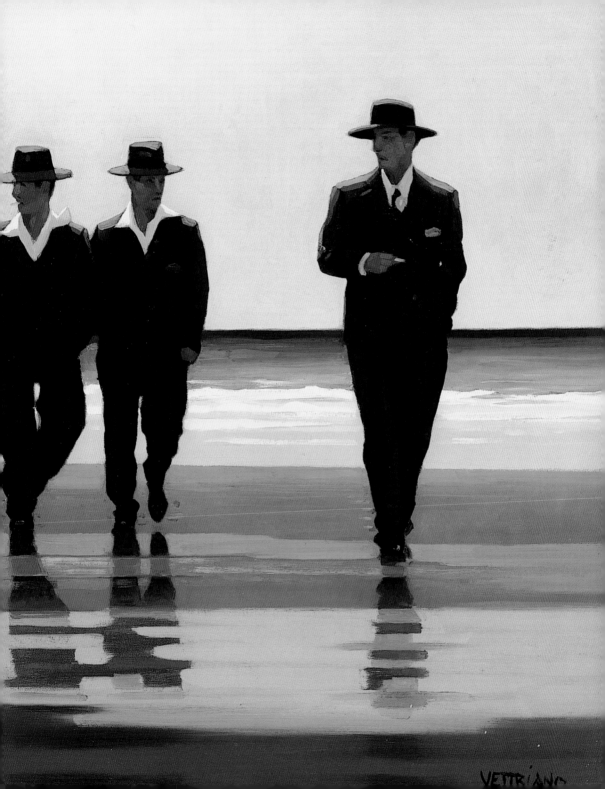

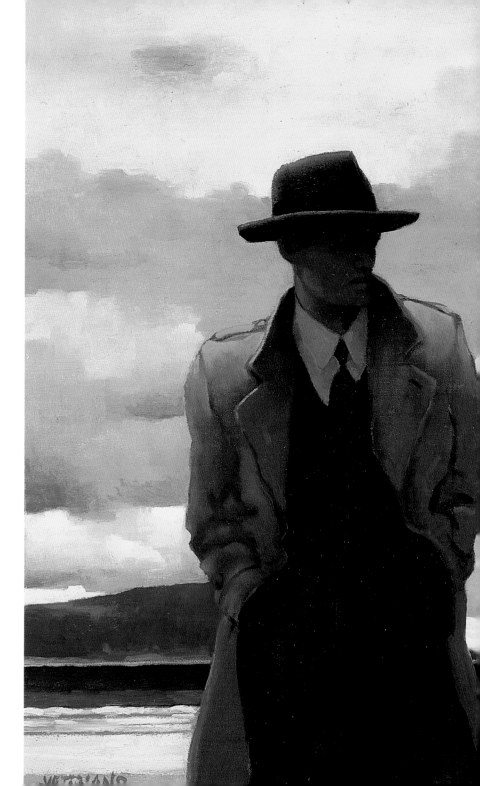

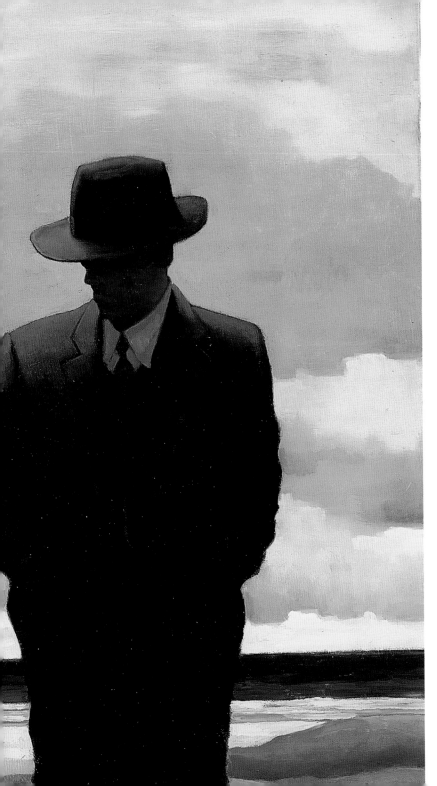

Amateur Philosophers

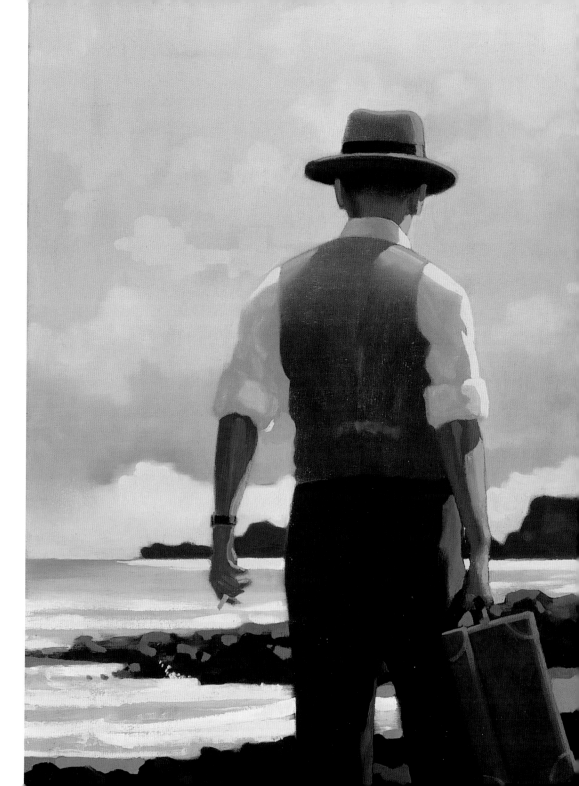

The Drifter

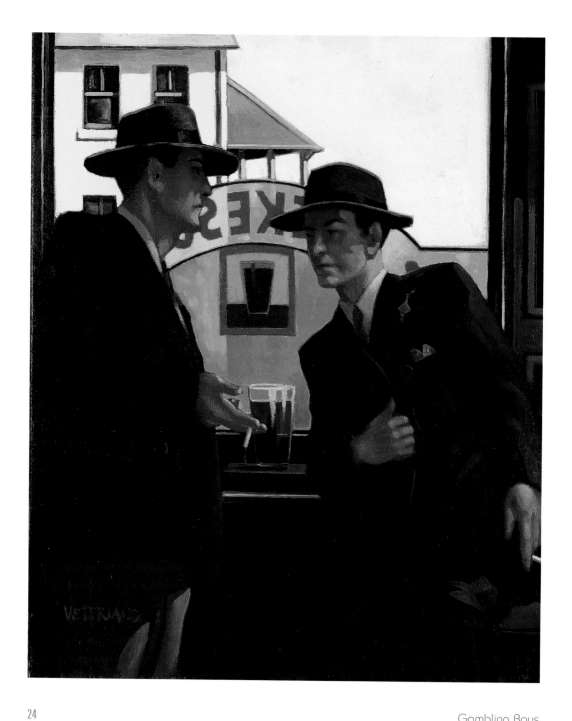

Gambling Boys

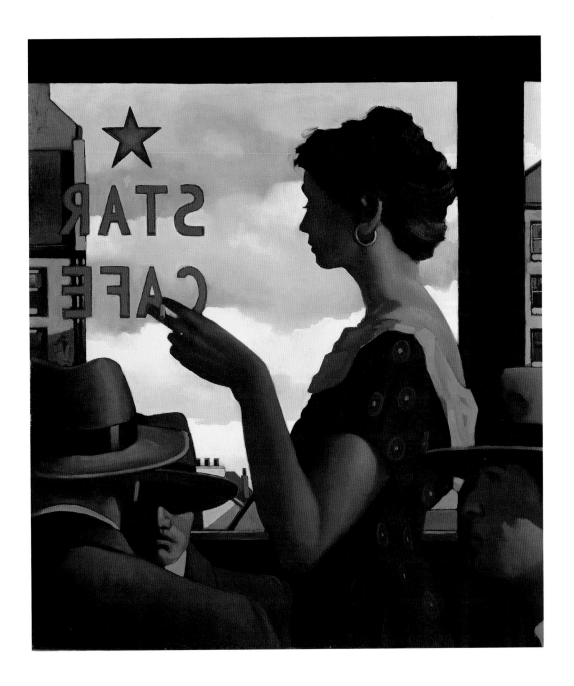

The Star Café

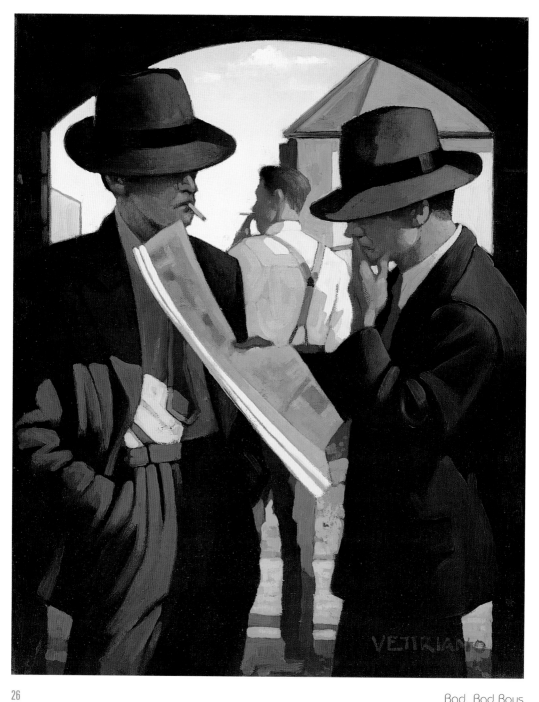

Bad, Bad Boys

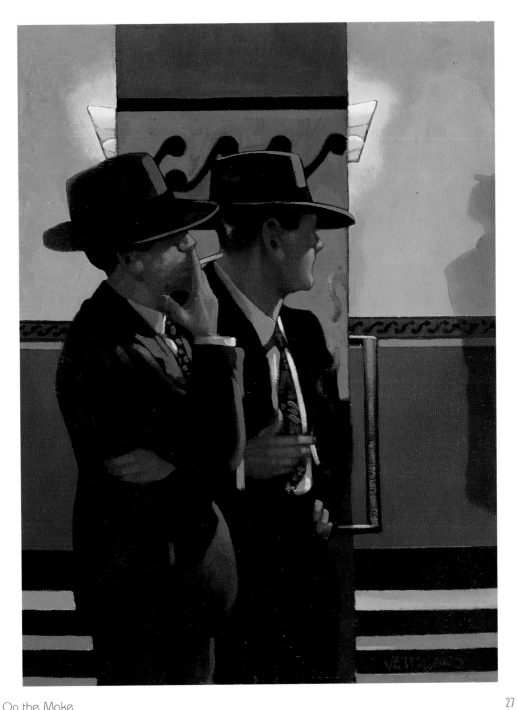

On the Make

Evening Racing

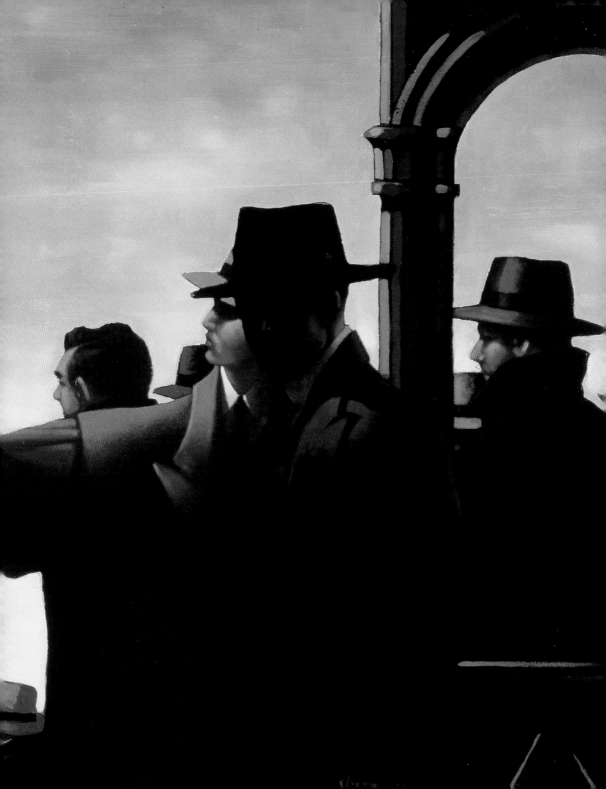

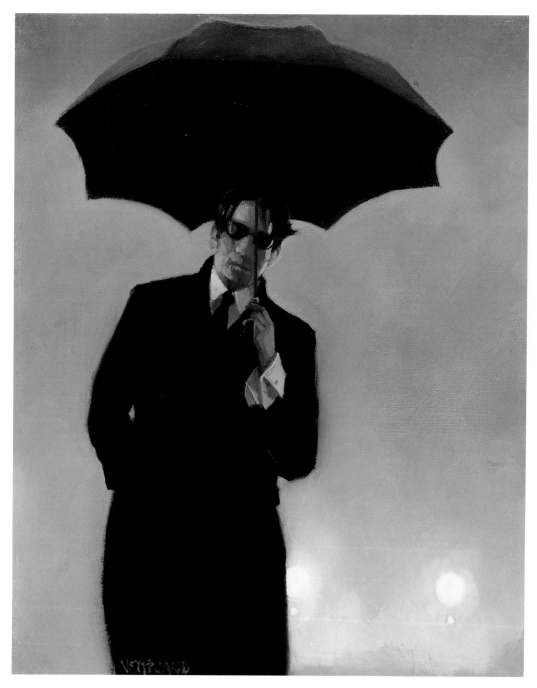

Man Pursued

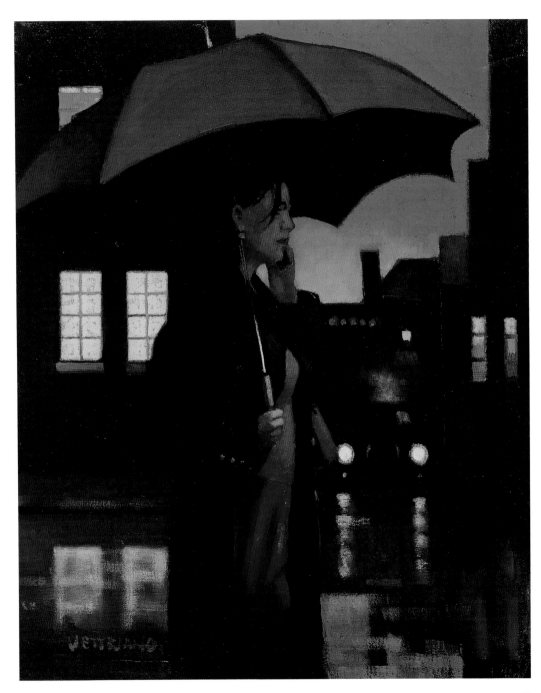

All Systems Go

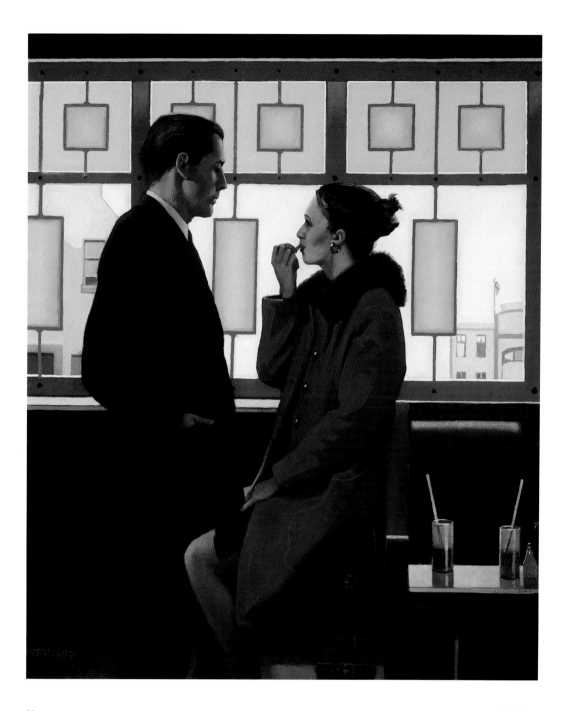

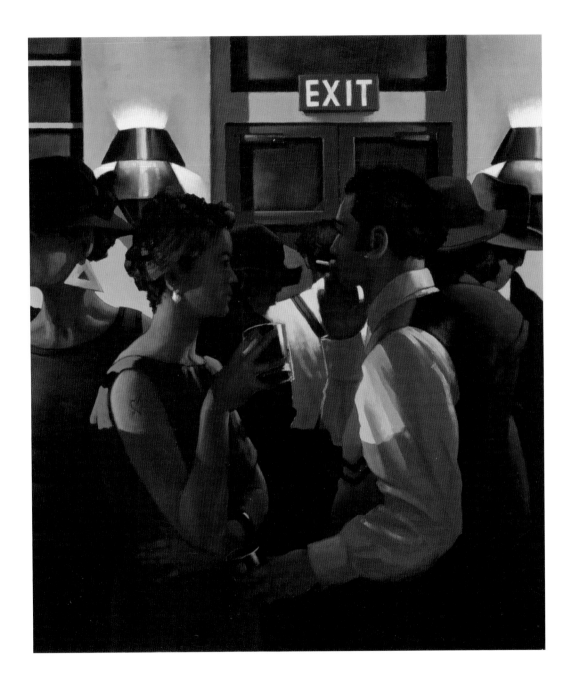

The City Café

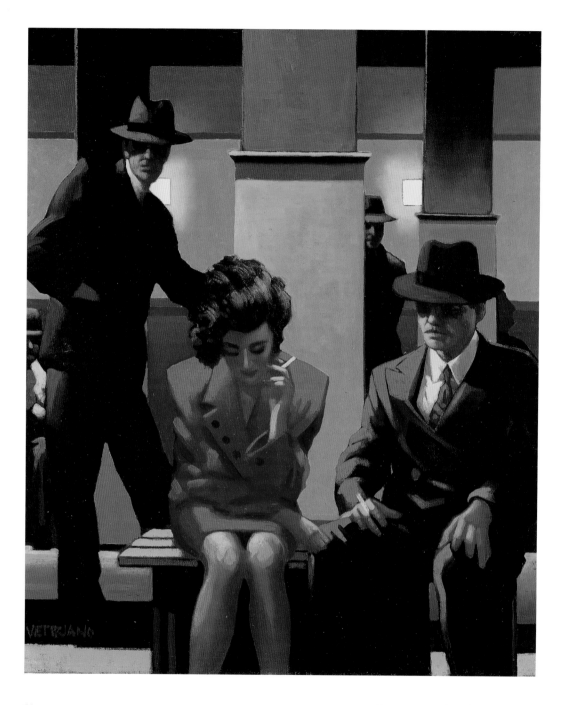

Sometimes it's a Man's World

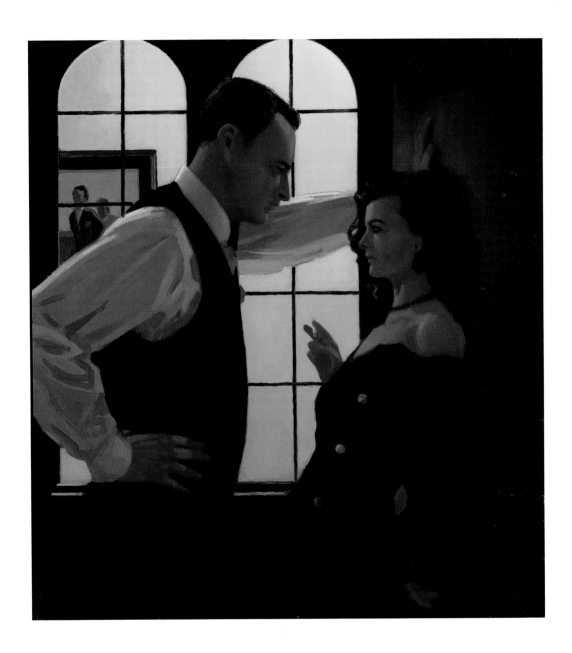

The Trap

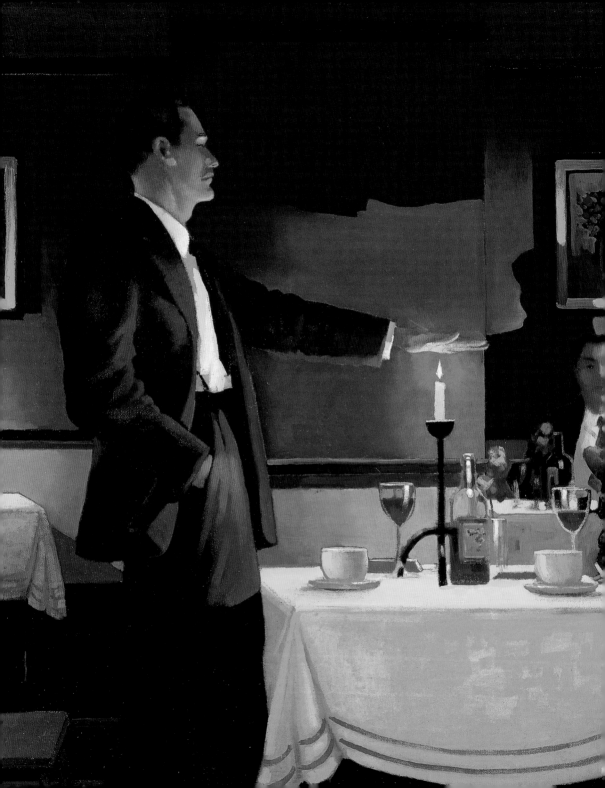

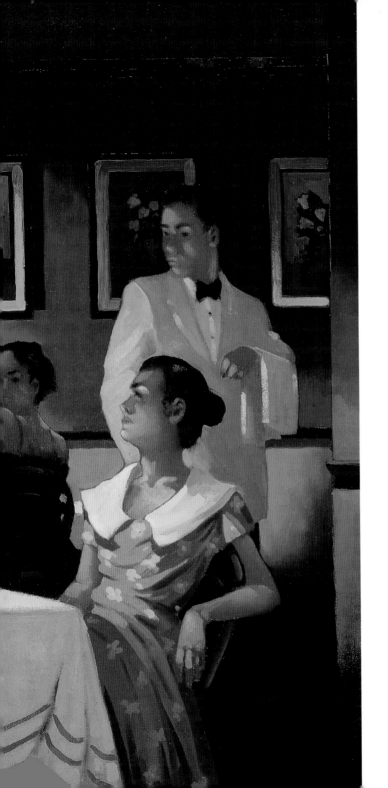

A Test of True Love

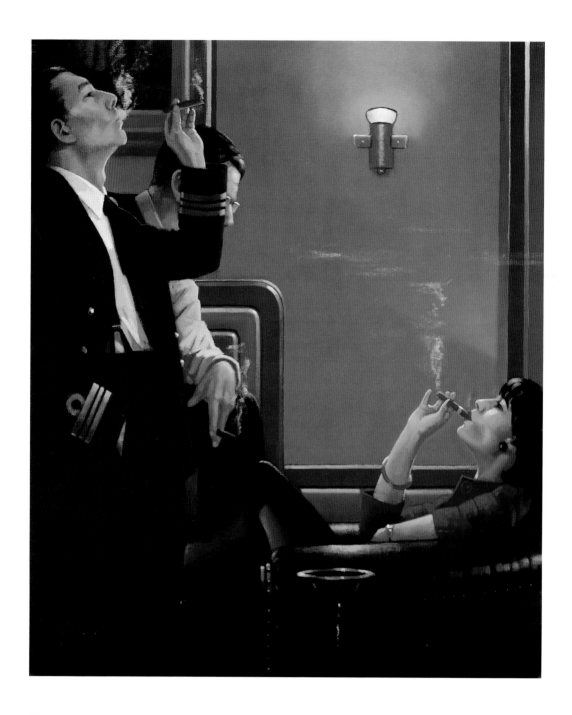

The Cigar Divan

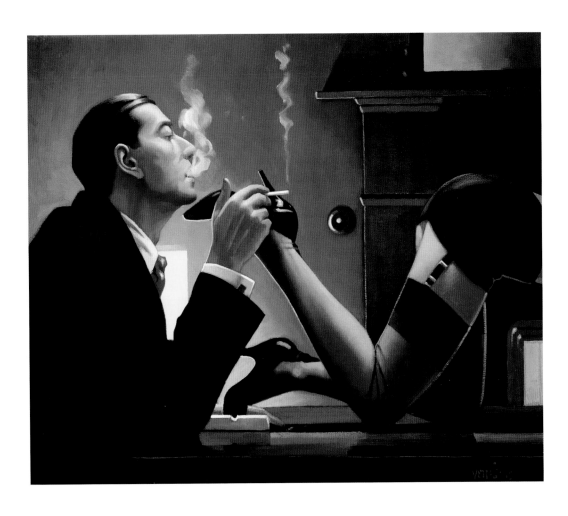

Fetish

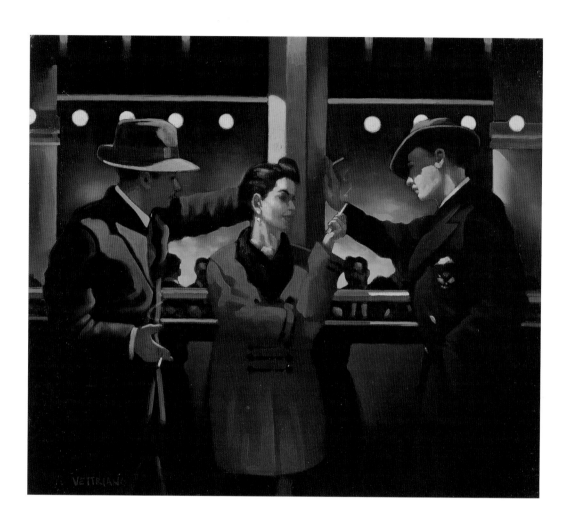

Cleo and The Boys

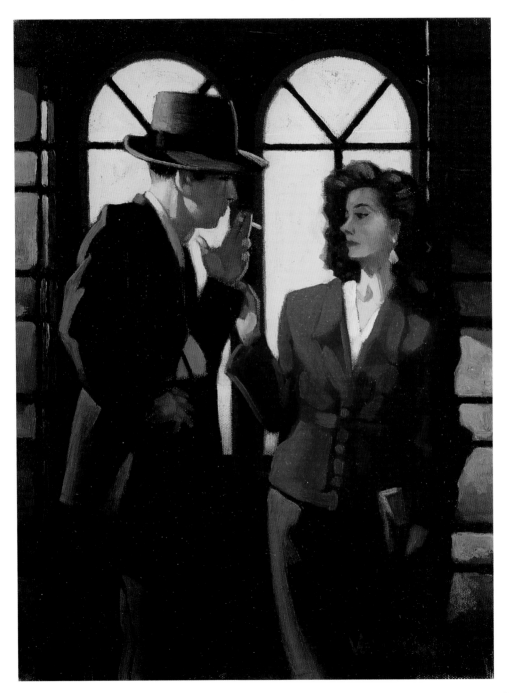

An Assignation

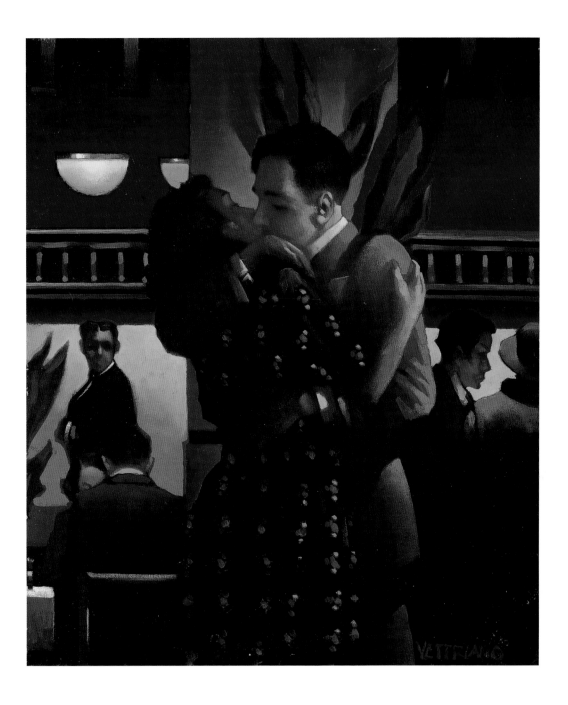

Betrayal, The First Kiss

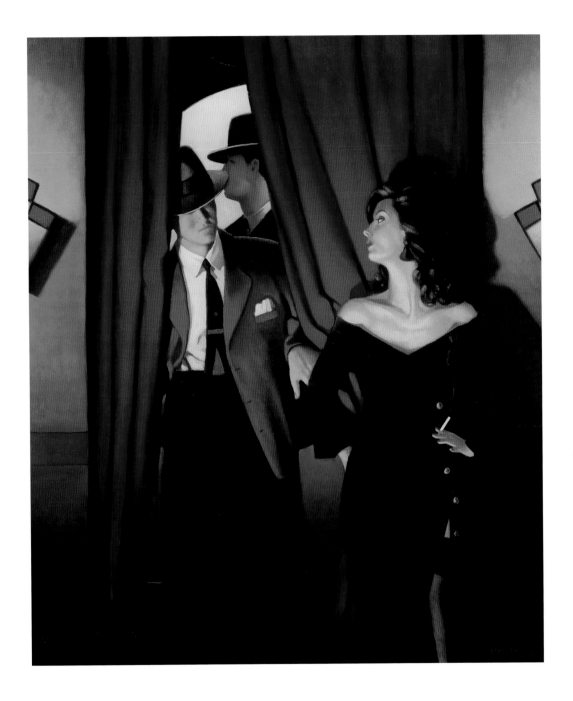

The Purple Cat

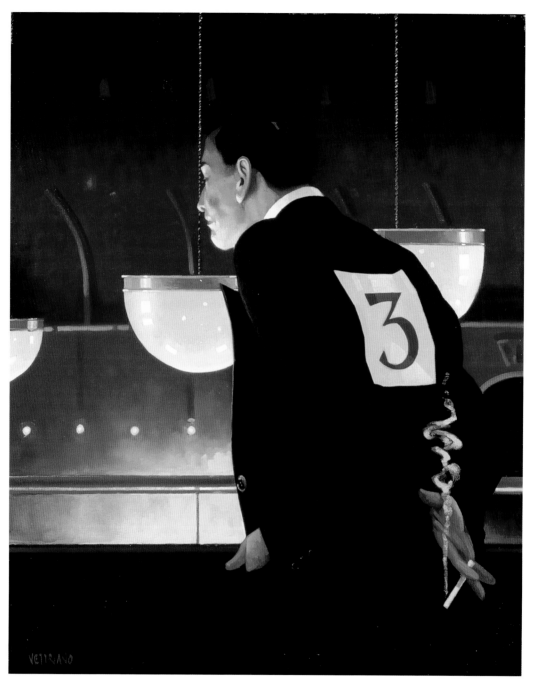

The Ballroom Spy

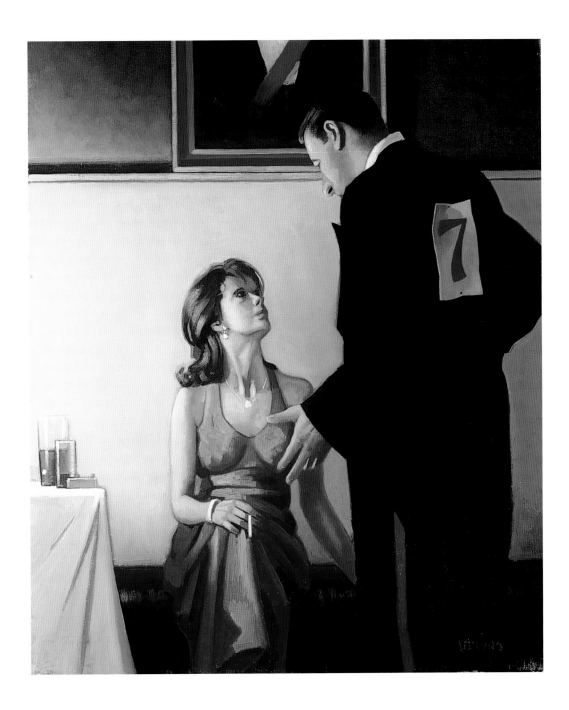

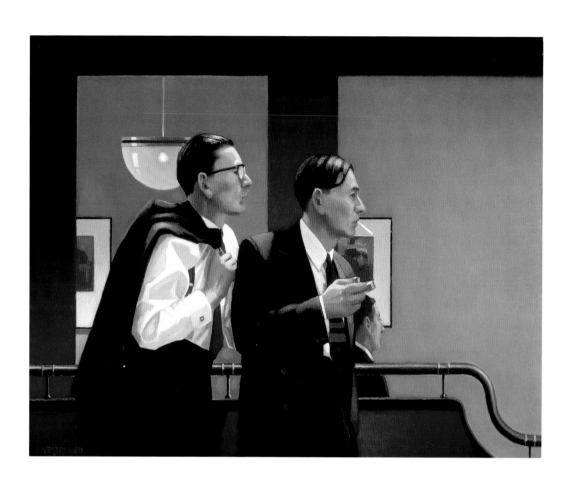

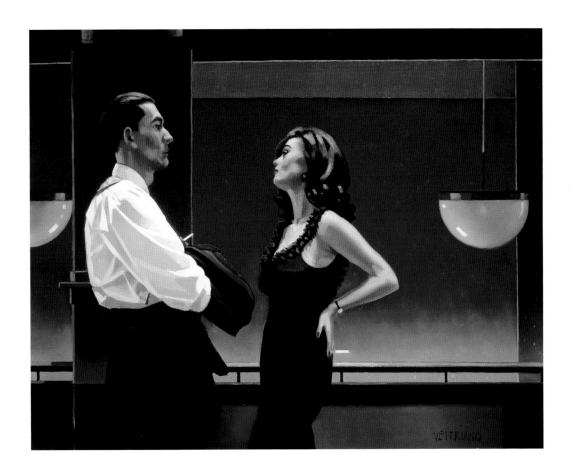

Incident at the Blue Lagoon

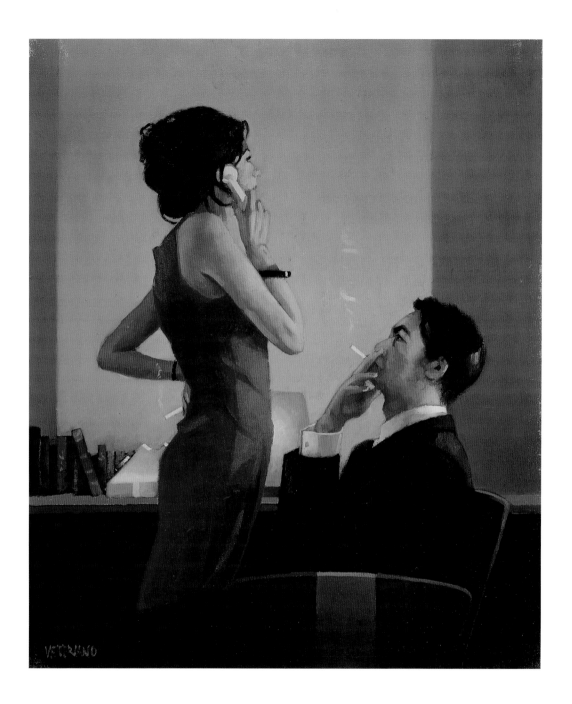

The Set Up

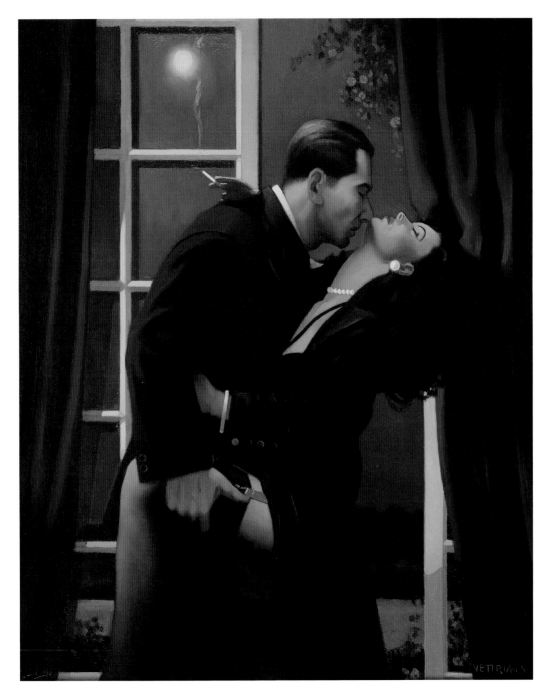

Night Geometry

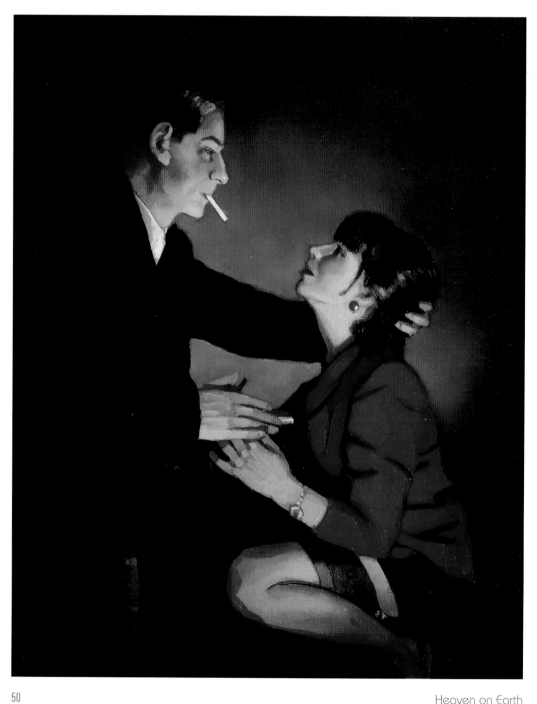

Heaven on Earth

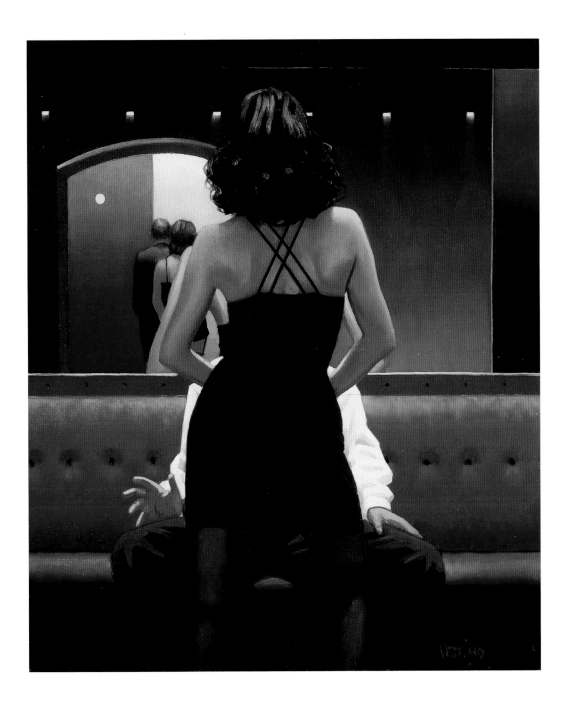

Private Dancer

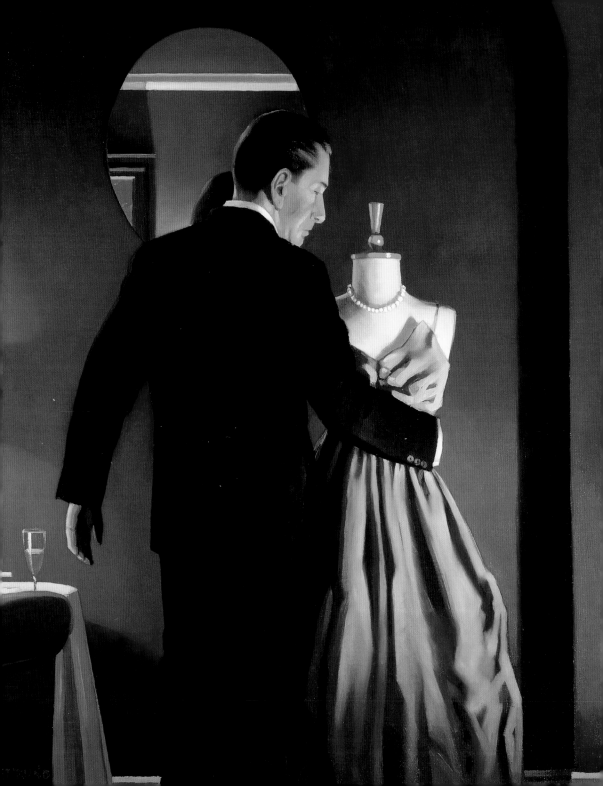

The Altar of Memory

Another Kind of Love

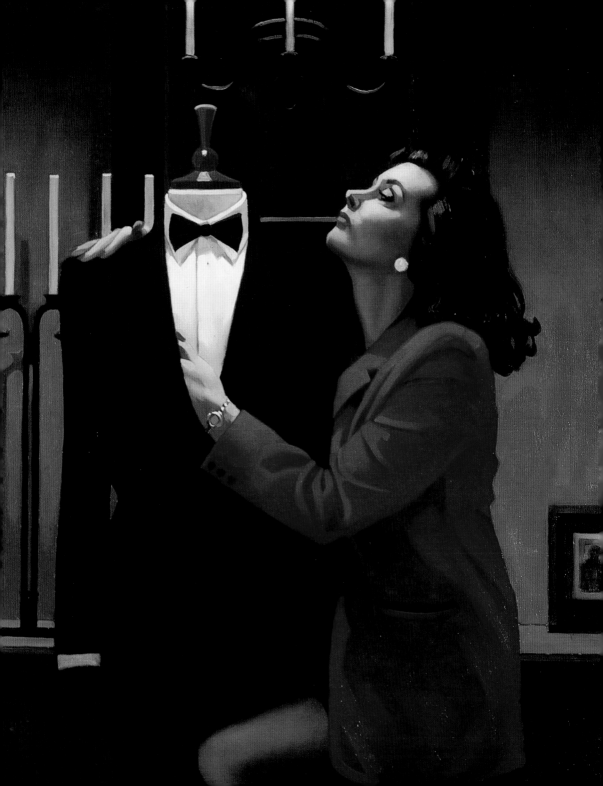

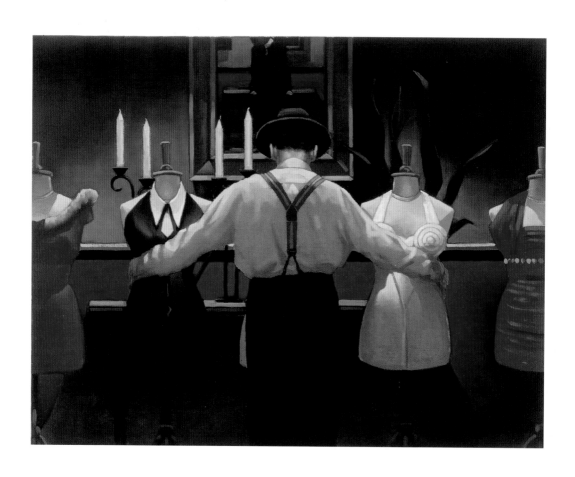

A Kind of Loving

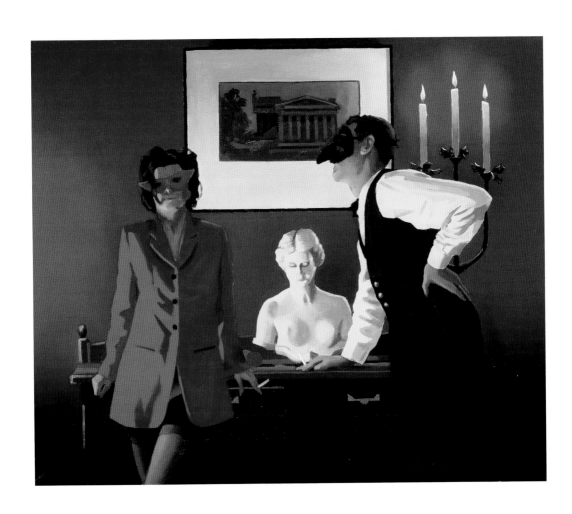

The Sparrow and The Hawk

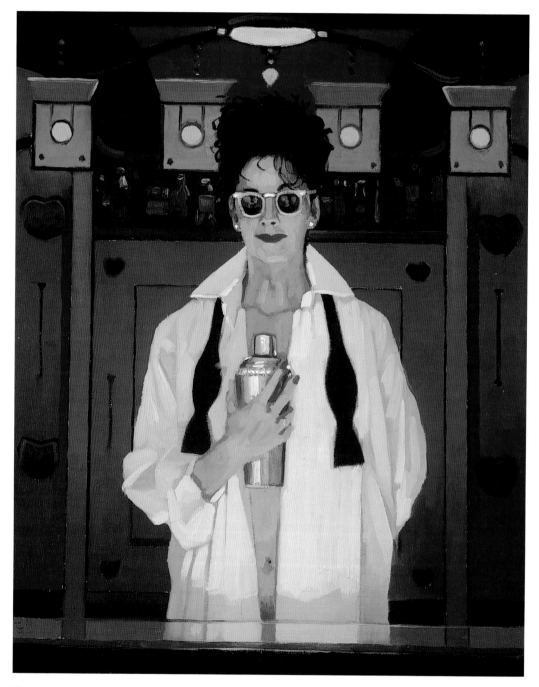

The Cocktail Shaker

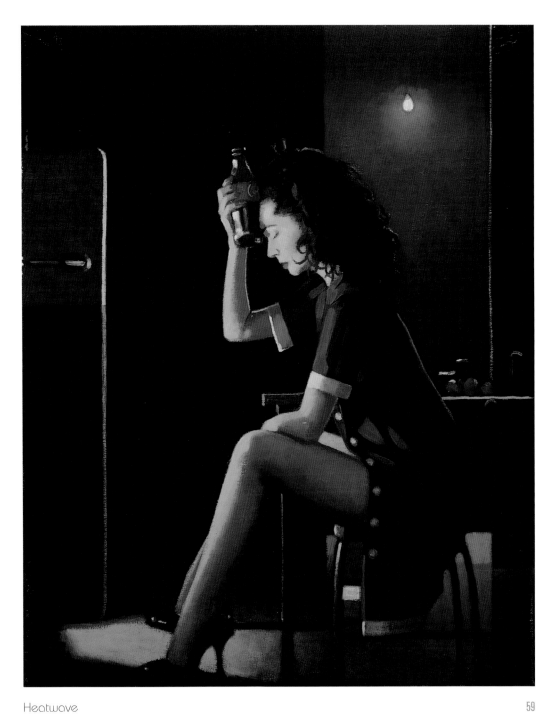

Heatwave

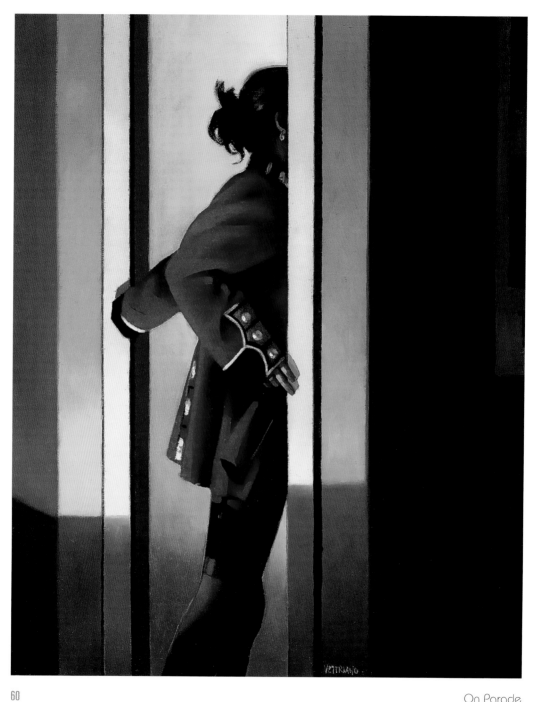

On Parade

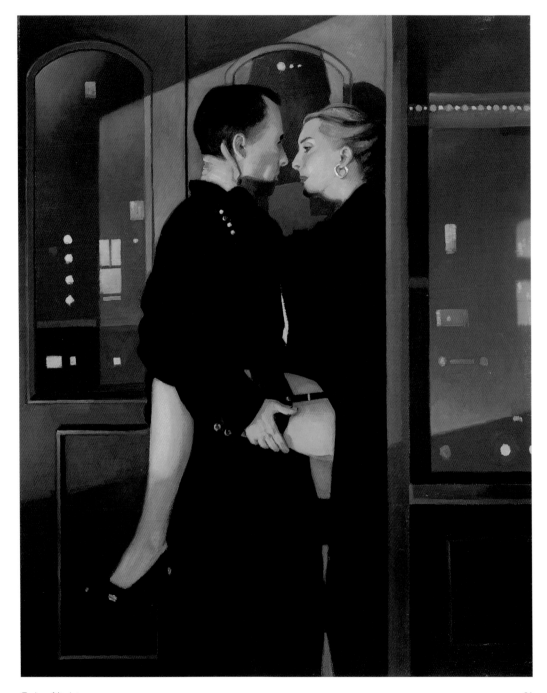

Soho Nights

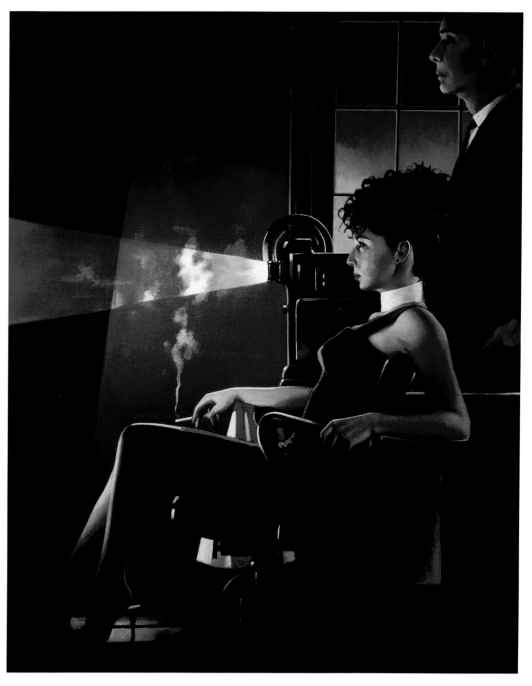

An Imperfect Past

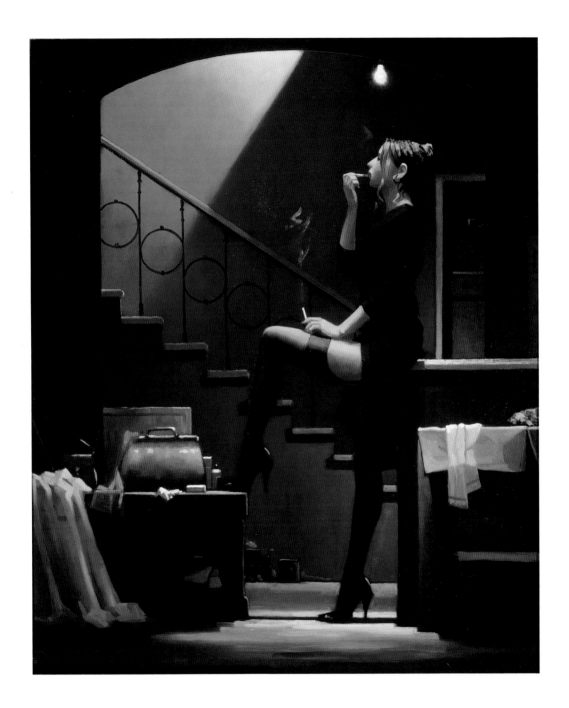

Dancer for Money

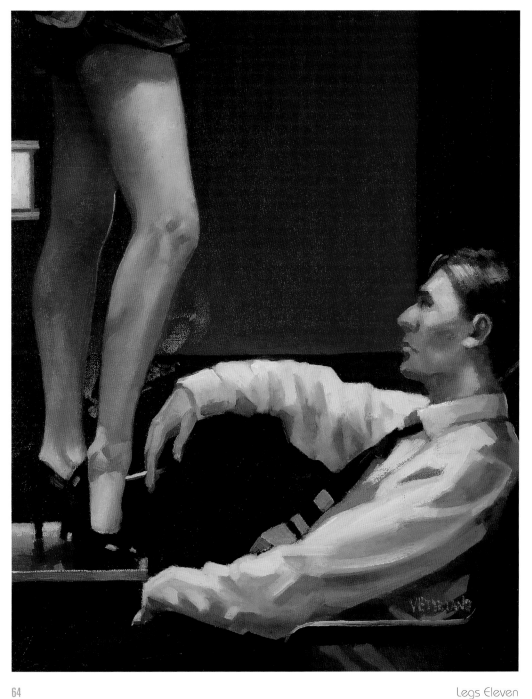

Legs Eleven

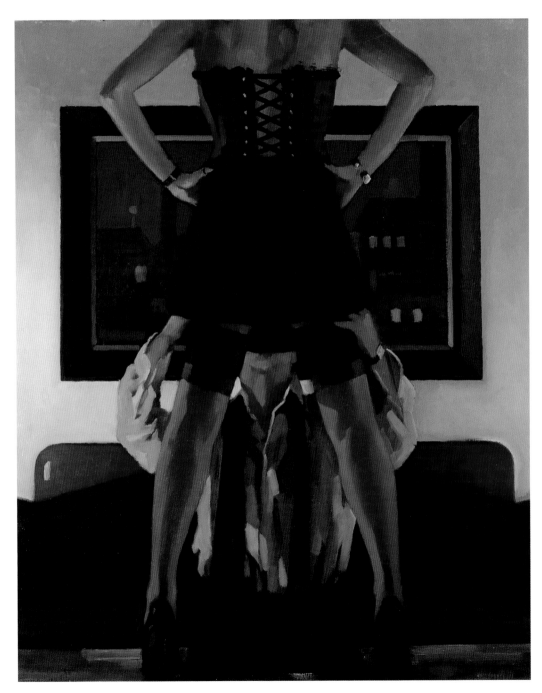

Devotion

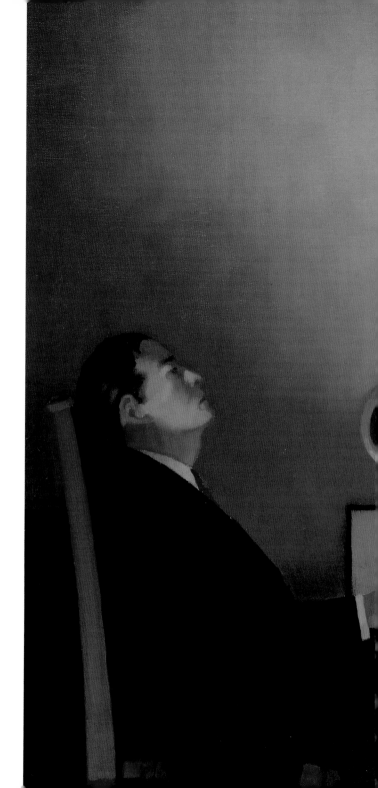

Beautiful Losers

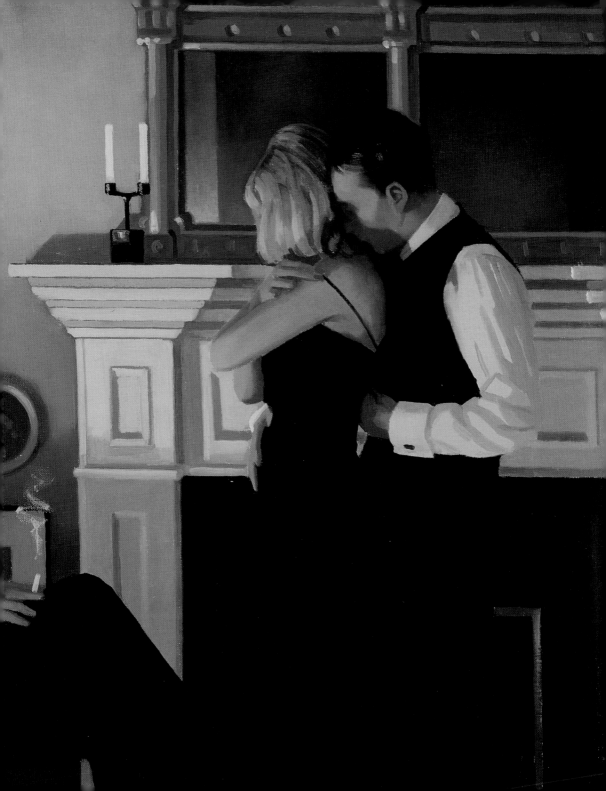

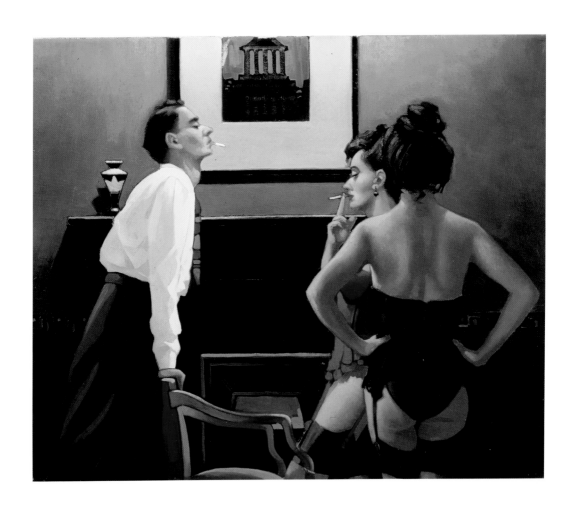

The Master of Ceremonies

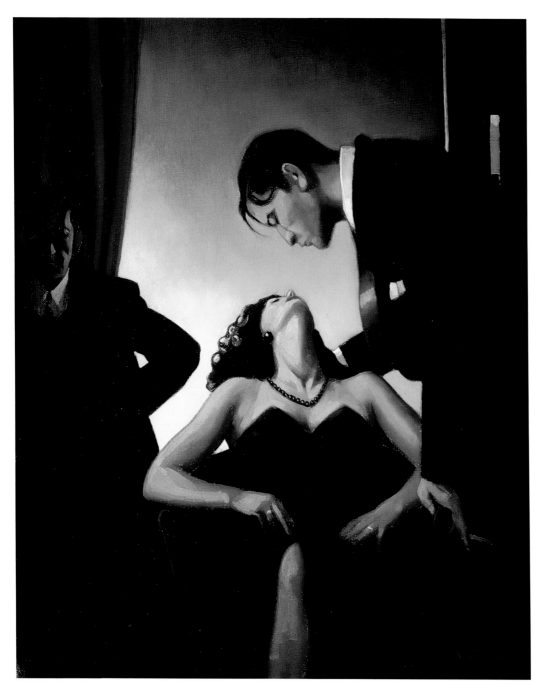

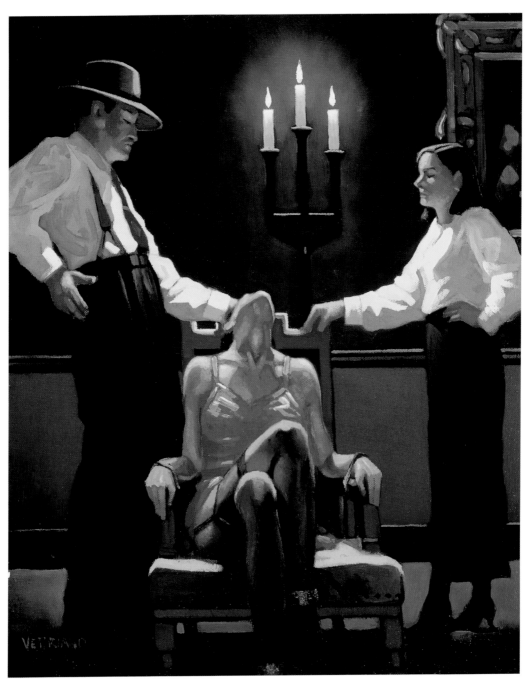

Setting New Standards

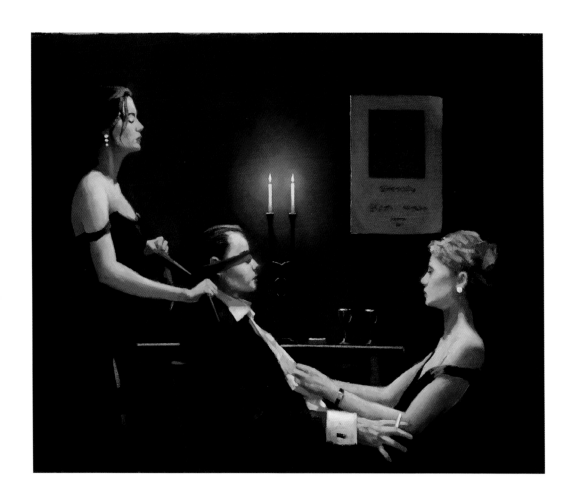

Wicked Games

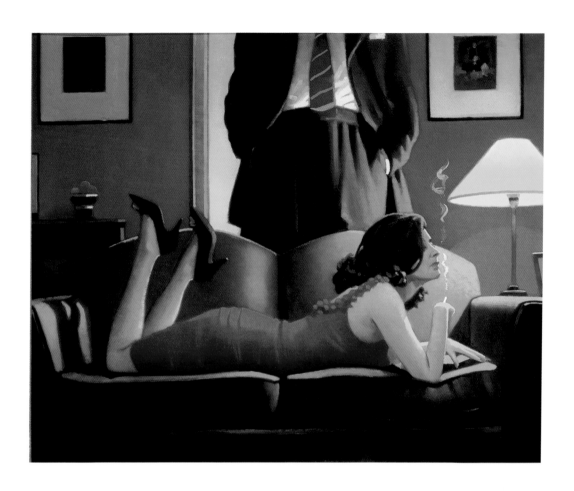

The Parlour of Temptation

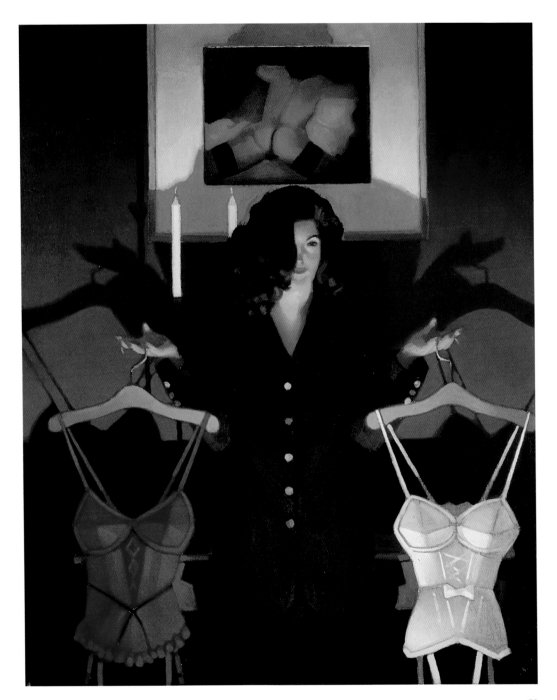

Heaven or Hell

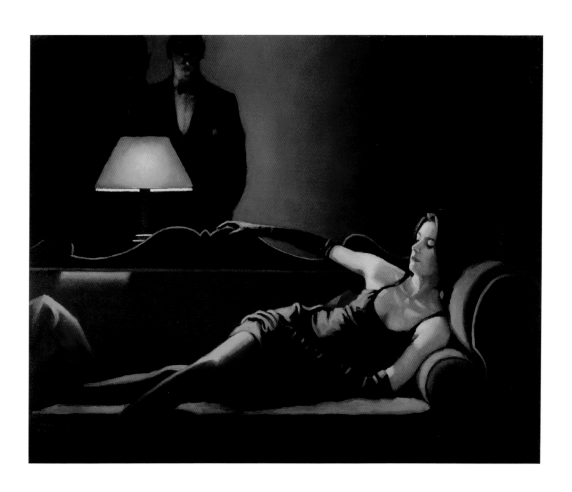

Along Came a Spider

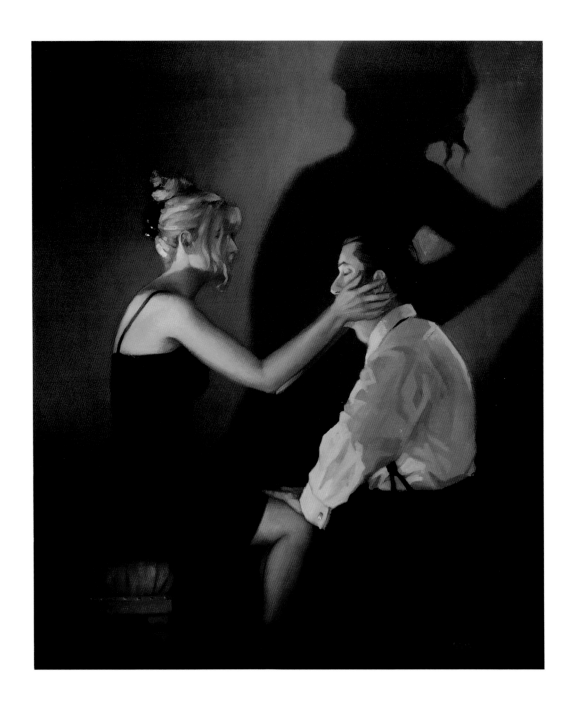

At Last, My Lovely

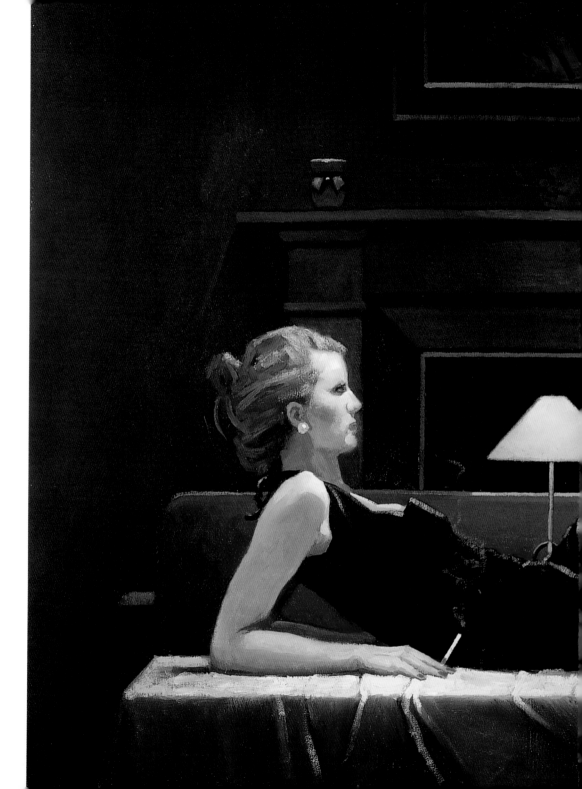

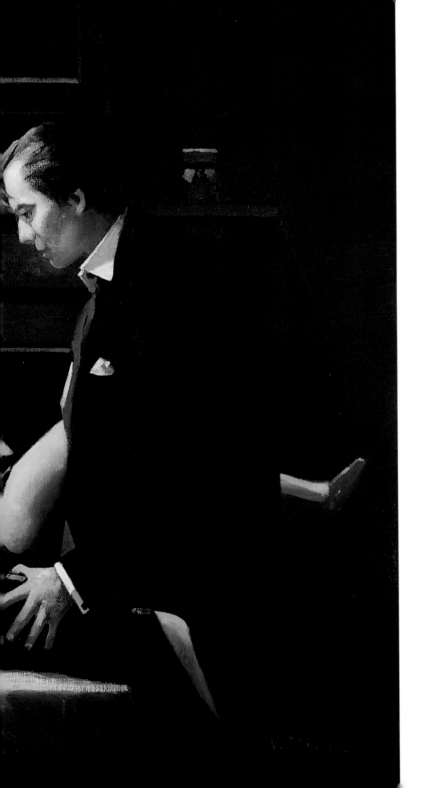

Passion Overflow

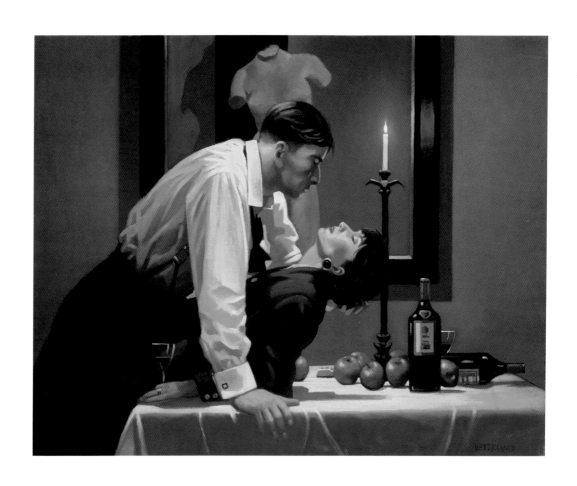

The Party's Over

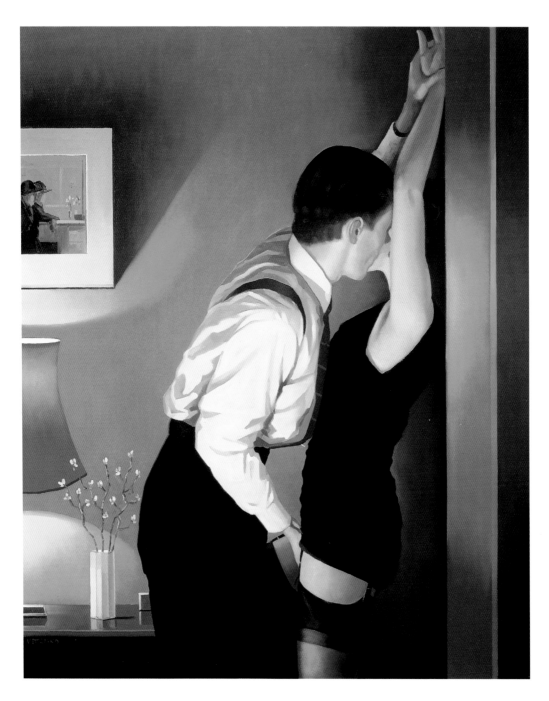

Game On

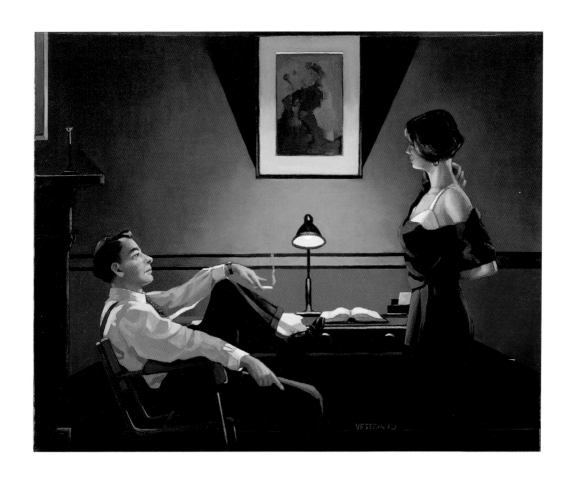

A Mutual Understanding

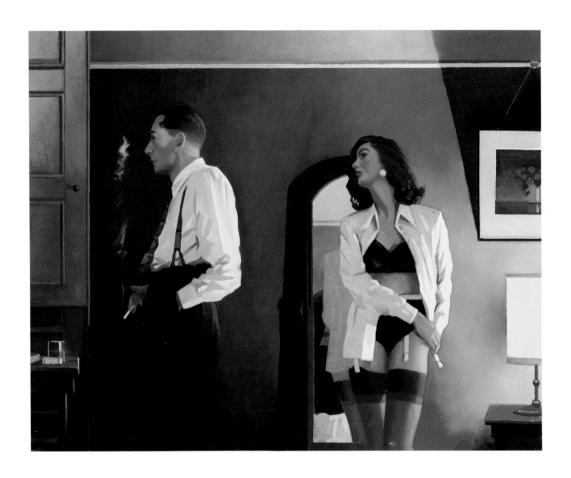

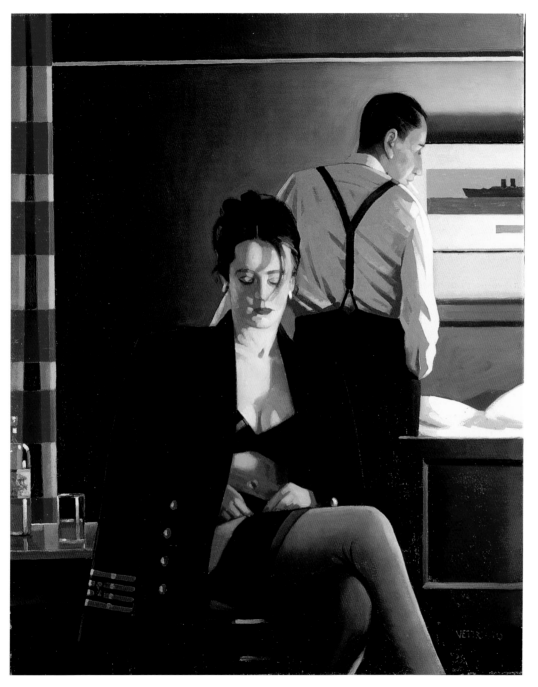

Sailor's Toy

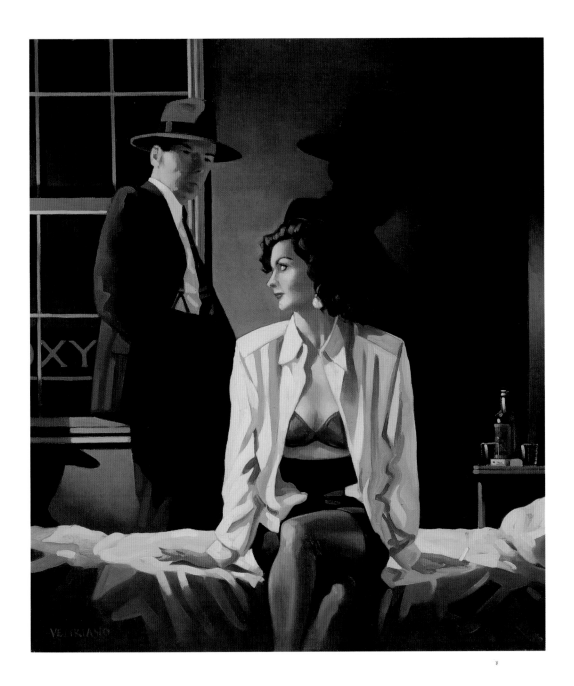

The Same Old Game

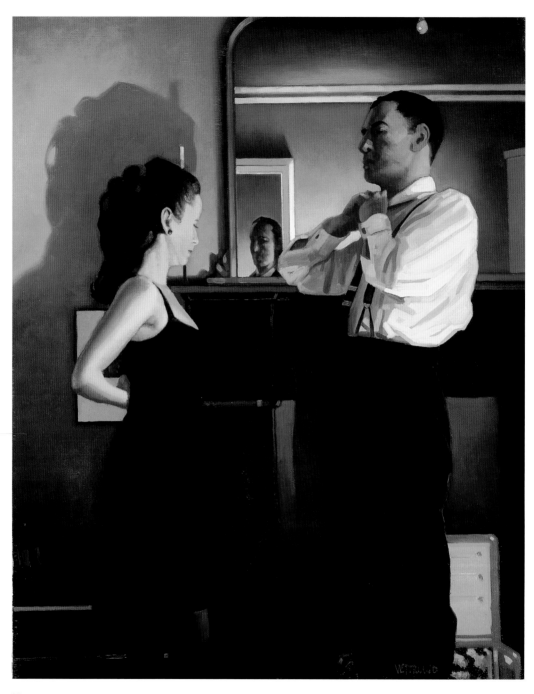

Between Darkness and Dawn

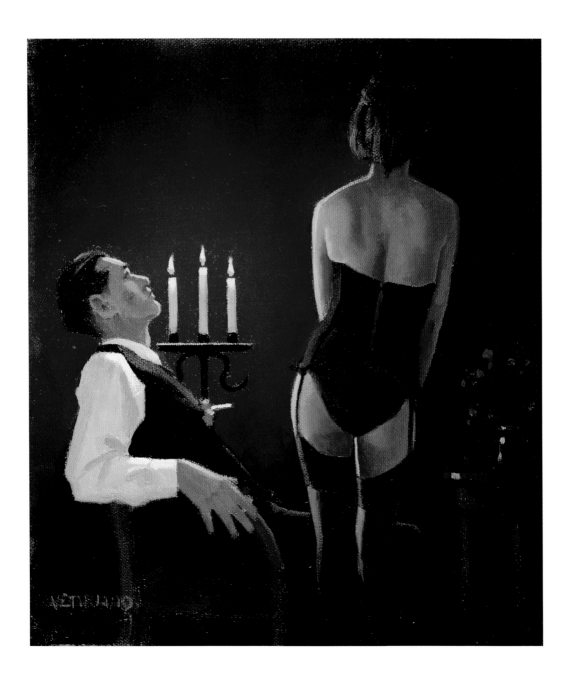

Master of Ceremonies (Study)

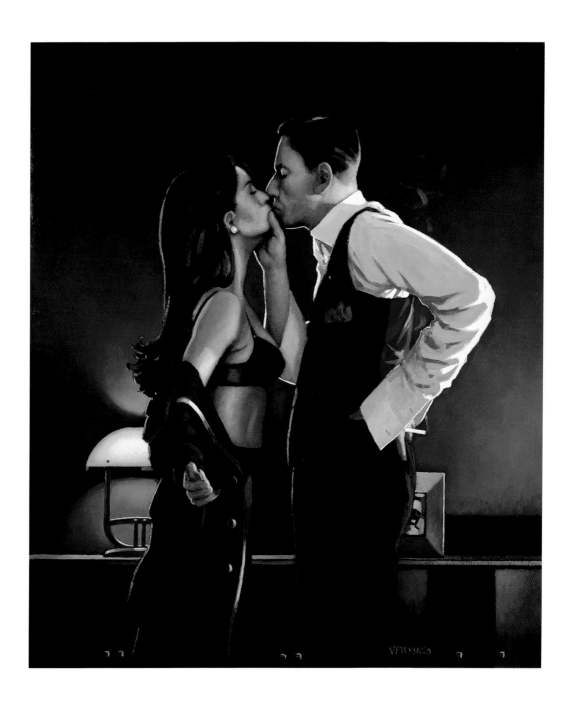

Pincer Movement

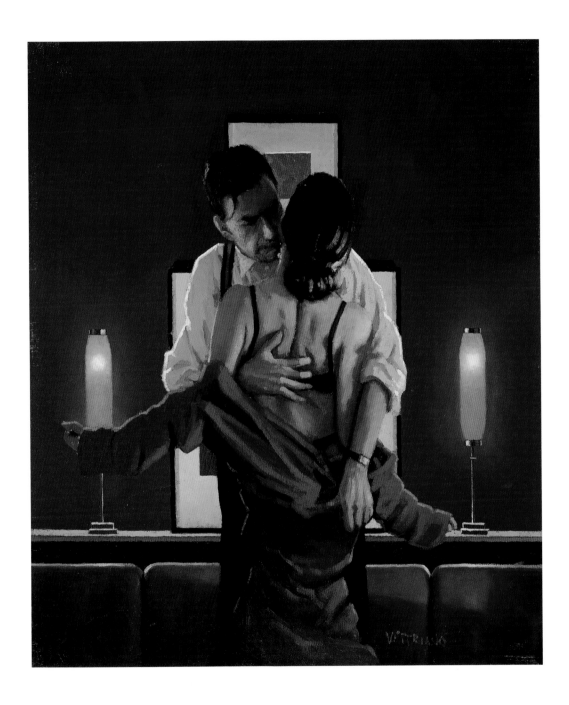

The Embrace of the Spider

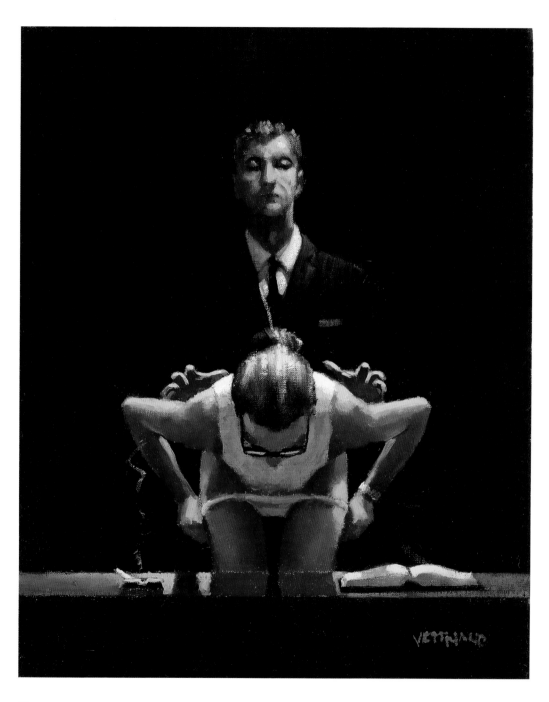

A Sinister Turn of Emotion

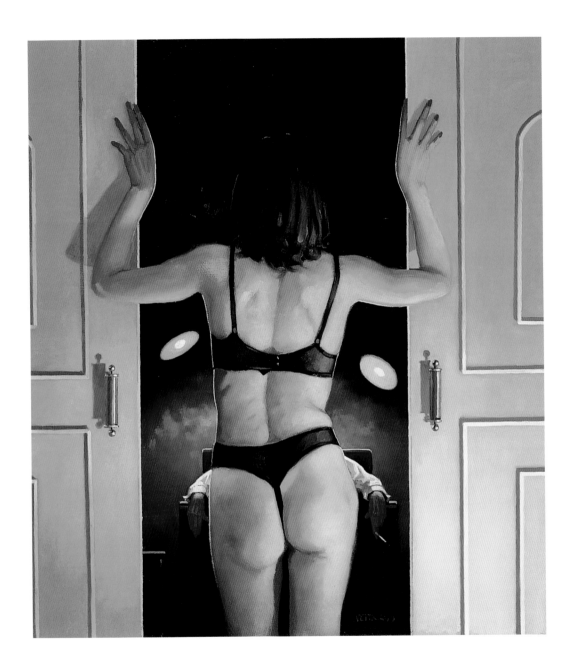

His Favourite Girl

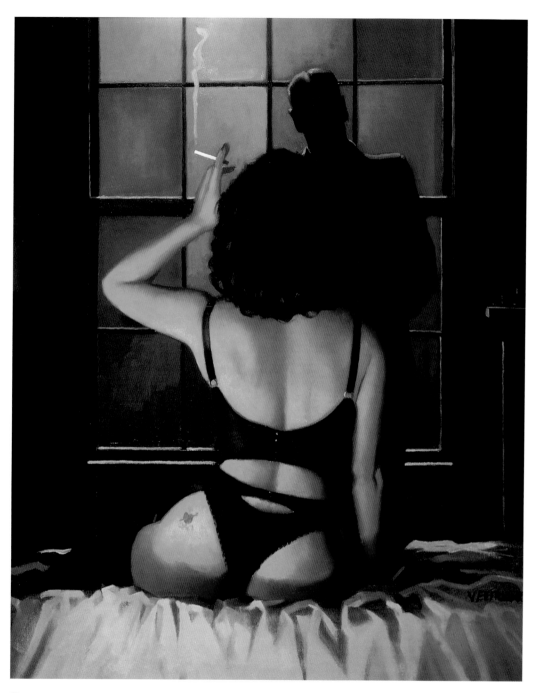

Round Midnight

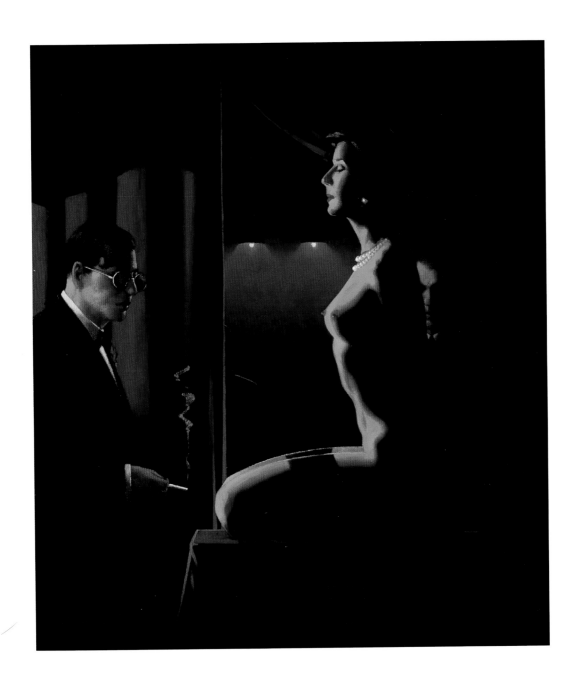

Just The Way It Is

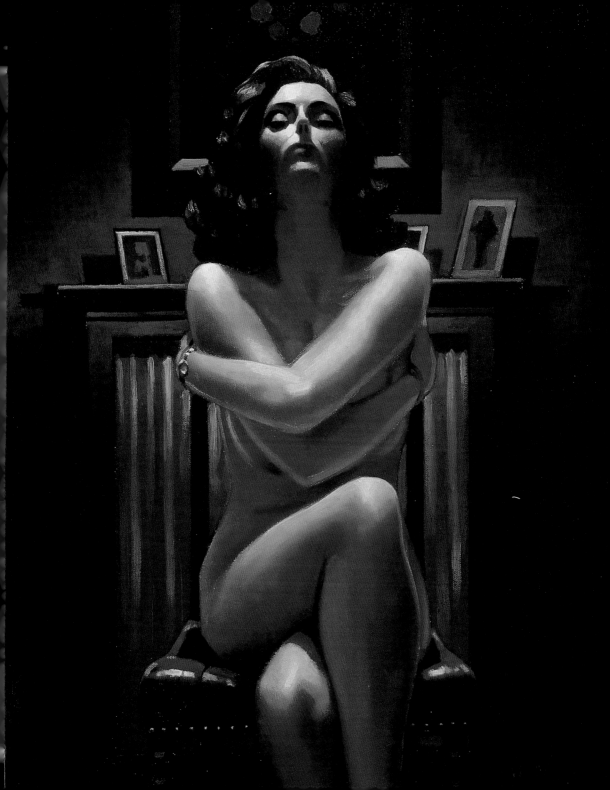

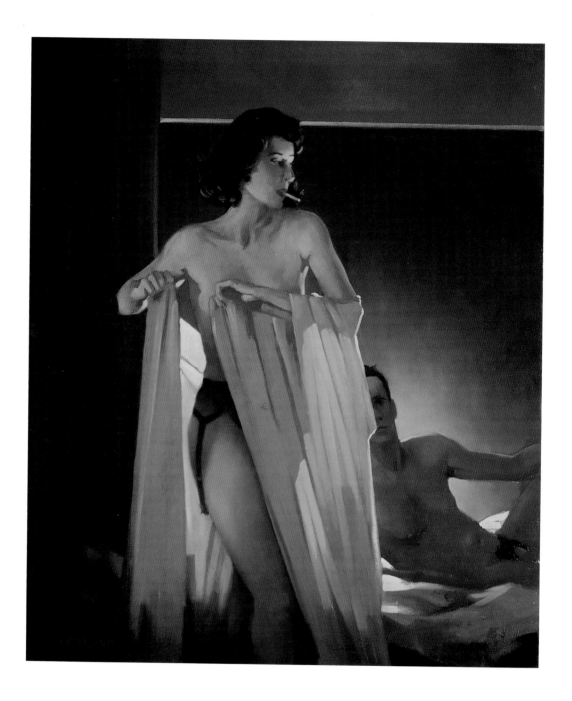

Under Cover of the Night

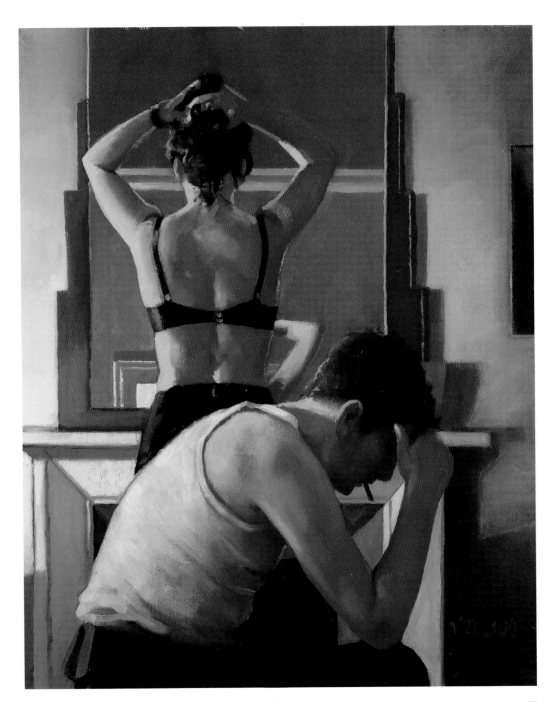

A Very Married Woman

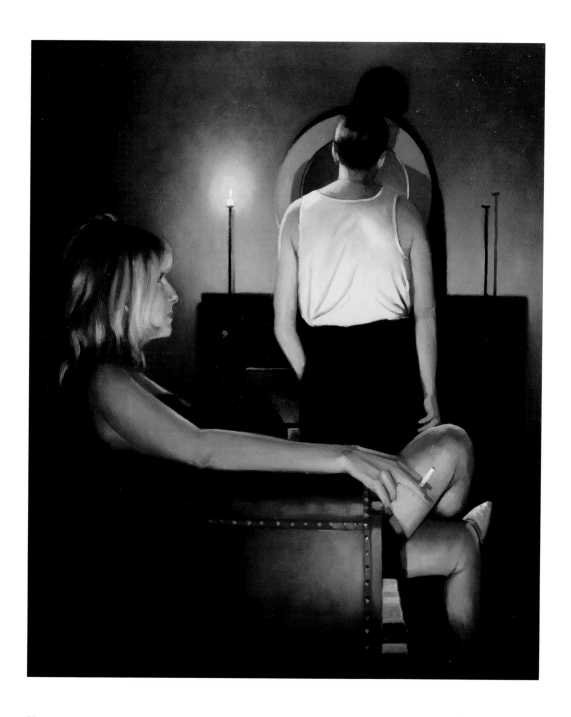

A Terrible Beauty

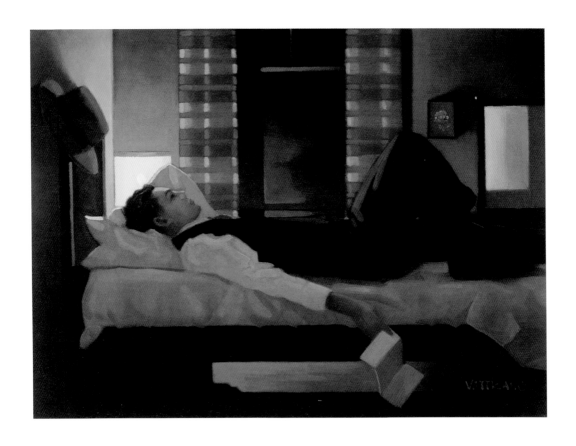

Heartbreak Hotel

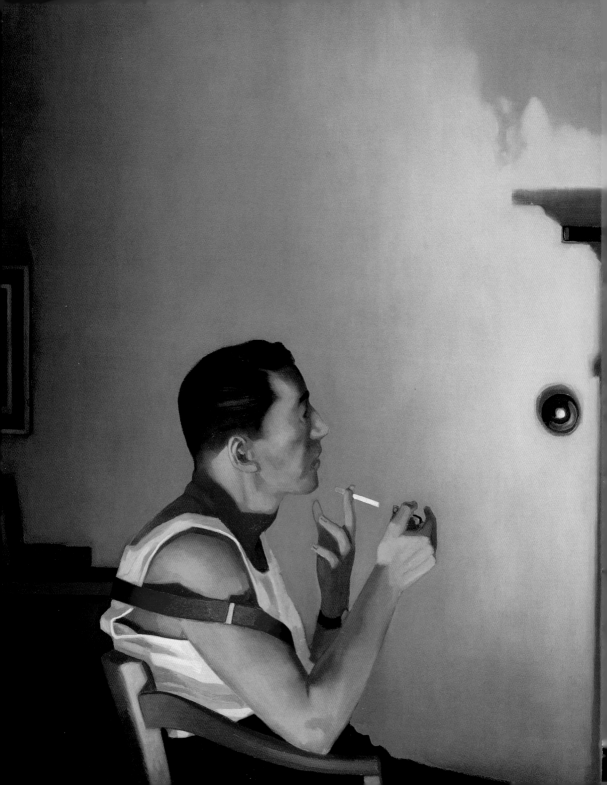

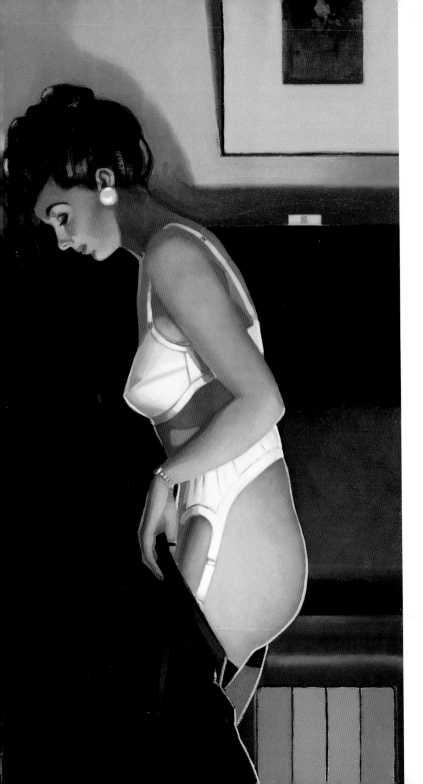

Rough Trade

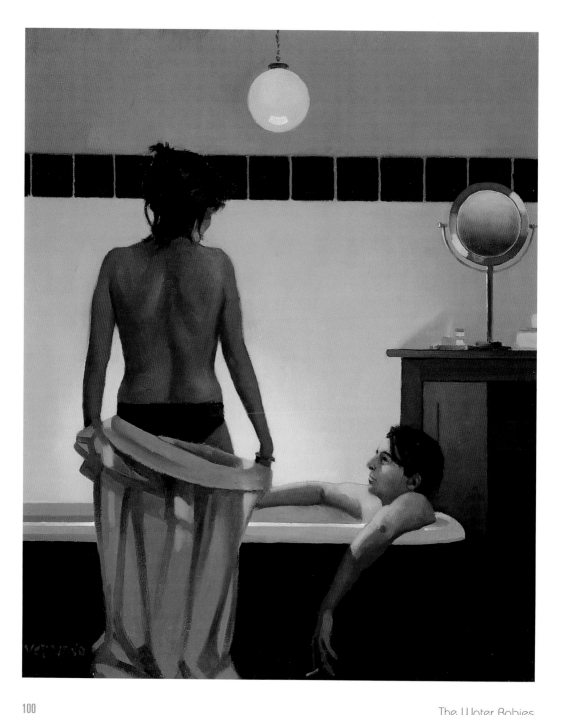

The Water Babies

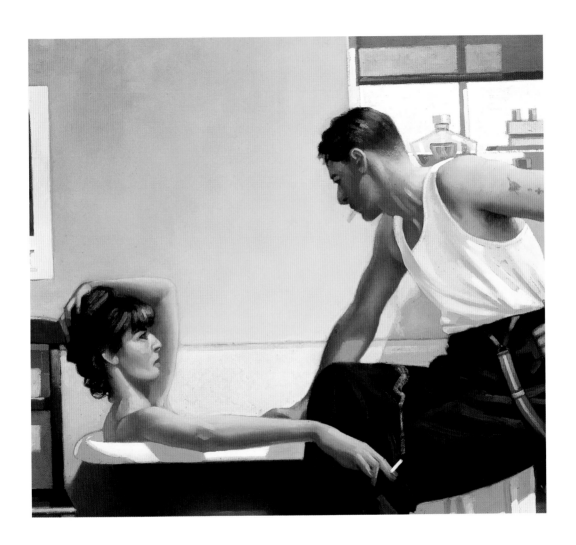

Bad Boy Blues

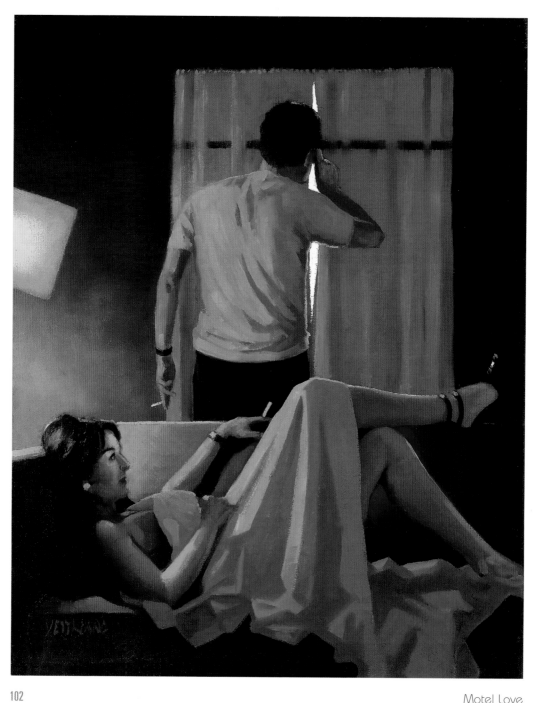

Motel Love

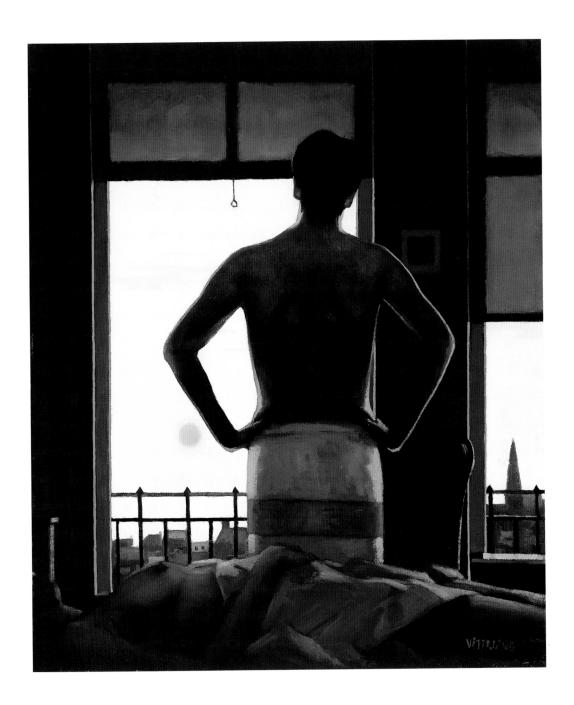

The Remains of Love

The Temptress

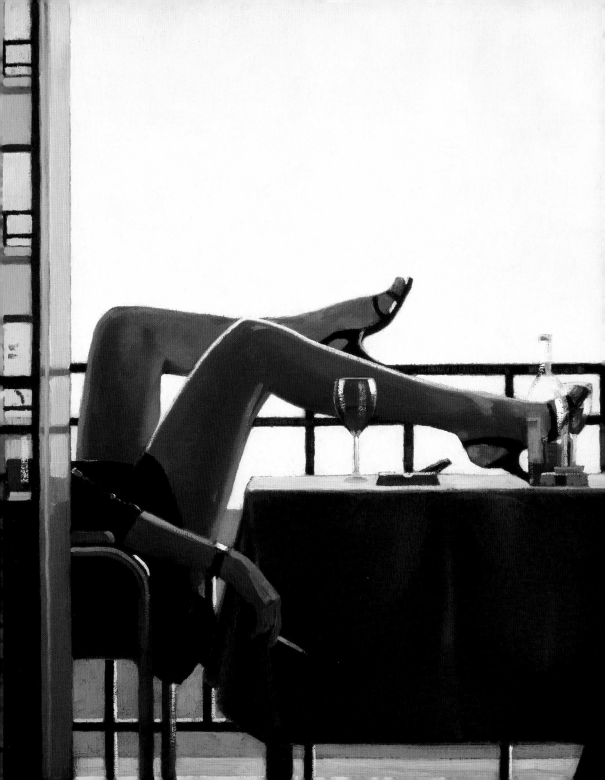

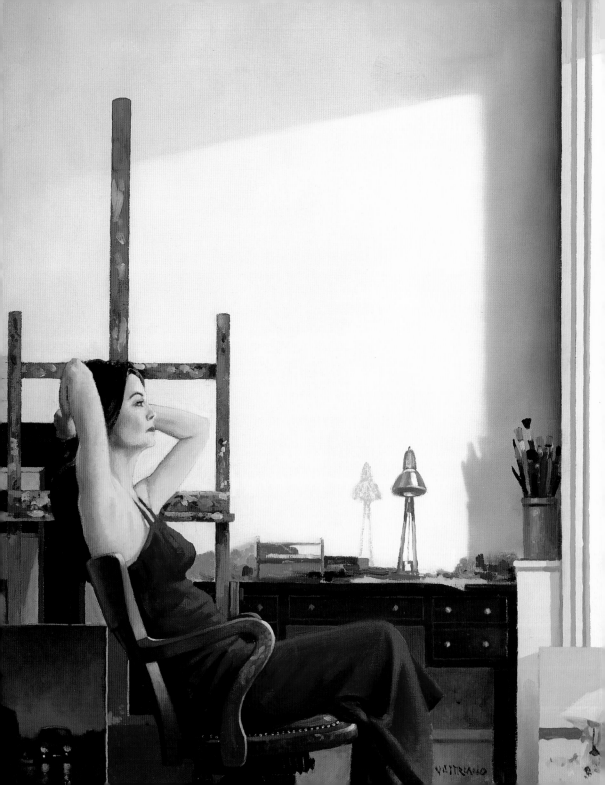

Studio Afternoon

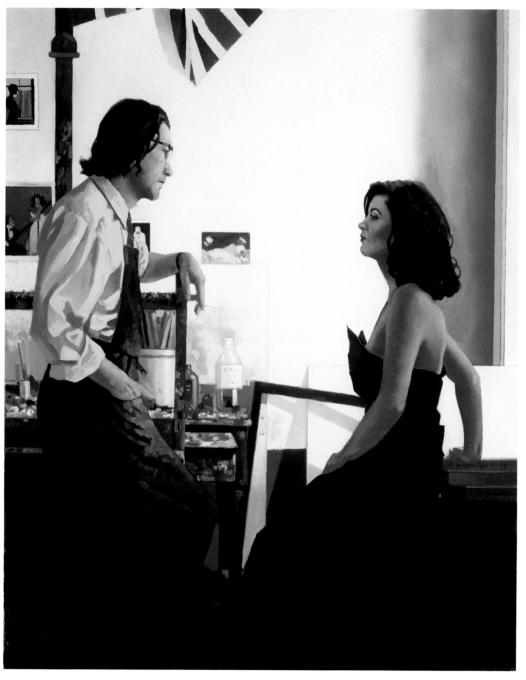

The Artist and Model

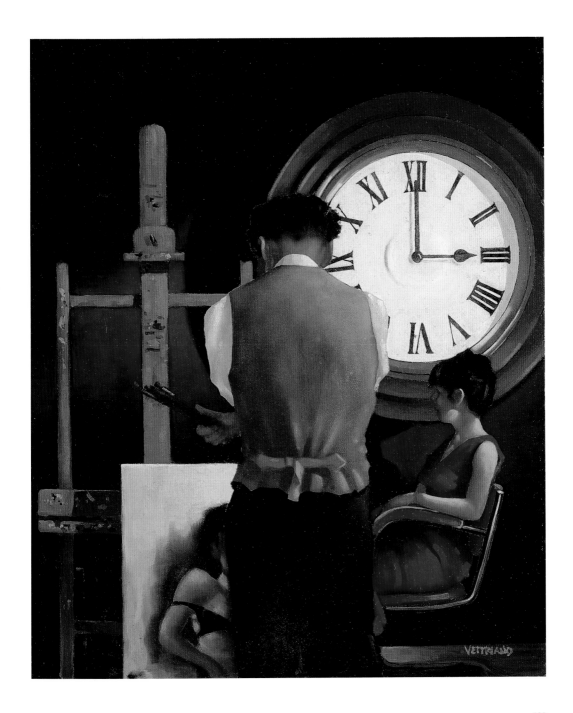

The Critical Hour of 3am

Index of paintings

First published in Great Britain in 2009
by Pavilion

An imprint of the Anova Books Company Ltd
10 Southcombe Street, London W14 0RA

Paintings © Jack Vettriano
Design and layout © Pavilion
Designed by Martin Hendry
Jacket Design by Georgina Hewitt

The moral right of the painter has been asserted

A CIP catalogue record for this book is available from the British Library.

ISBN 978 1 86205 856 9

Printed and bound by 1010 Printing International Ltd, China

10 9 8 7 6 5 4 3 2 1

This book can be ordered direct from the publisher. Please contact the Marketing Department.
But try your bookshop first.

www.anovabooks.com

For further information on Jack Vettriano please visit www.jackvettriano.com